Complete Guide to
Filters for Digital Photography

JOSEPH MEEHAN

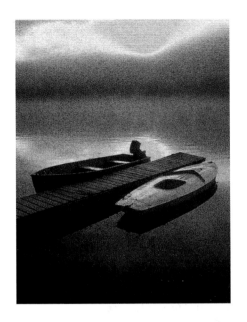

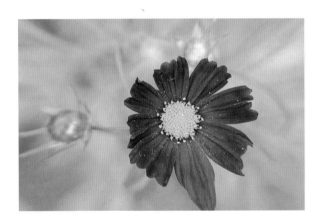

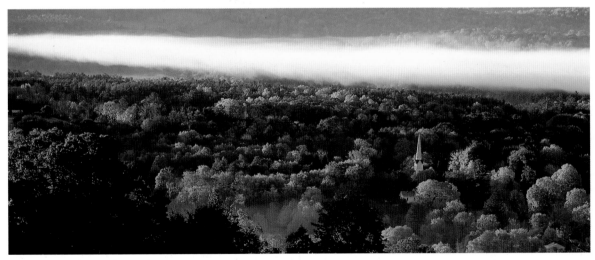

LARK BOOKS

A Division of Sterling Publishing Co.,Inc.
New York

Table of Contents

Introduction

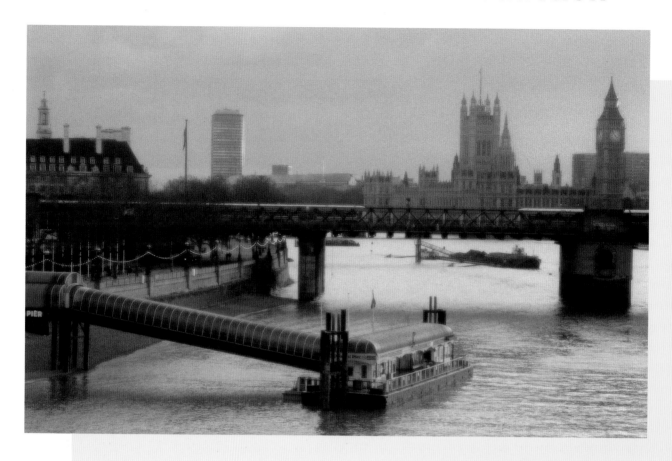

Modern film and digital cameras represent a remarkable level of technical achievement in which most picture-taking functions have been automated. Yet, despite all of these advances, there are many circumstances that still require the photographer to apply knowledge about conditions not covered by the camera's automation. One important example is the need to understand how the various qualities of natural and artificial light will produce very different effects in a final image.

Consequently, a knowledgeable photographer understands that each light source will have its own specific color characteristics. These characteristics will influence everything from how colors reproduce to the overall mood of the scene. The well-informed photographer also realizes that the human visual system is constantly adjusting to accommodate such differences while the camera only records what is there.

In addition to being sensitive to the physical characteristics of different light sources, a photographer will frequently strive to alter or correct some visual aspect of a subject or a scene. For example, in the portrait studio, eliminating skin imperfections and blemishes is likely to be well received by the client. On the other hand, a landscape photographer usually wants tack-sharp pictures while looking for ways to separate out various picture elements such as white clouds against a blue sky. And then there is the constant struggle among all photographers to capture detail in both deep shadow and bright highlight areas. One of the most effective tools a photographer has to obtain these and many more results is the use of camera filters in all their various forms.

Besides these "corrective" applications, creative photographers use filters to alter some aspect of a picture to fit their own interpretations. For example, they often establish a particular mood through the use of soft focus or diffusion filters as well as "warming" or "cooling" filters. Then there are cases when the photographer may want to add something to the scene that was not there originally. Graduated color filters, for example, are extremely effective at converting a dreary sky into an area that adds new strength and balance to a composition. Adding diffusion, enhancing a color, or even placing a small star burst within a candle flame can all play a role in the photographer's interpretation of a subject or a scene.

All of these effects are examples of the second, or "creative role," of filtration. This is one of the most exciting aspects of filter use, since it is determined by the photographer's willingness to be experimental and creative. Many professional and serious amateur photographers rely on various forms of filtration for at least part of their particular photographic style and the characteristic look of their images.

In recent years, the growth of digital photography and the development of specialized filter programs for the computer have greatly expanded the ability of the photographer to affect the final image. Examples range from the filter sets and other controls contained in such powerful image software programs as Adobe's Photoshop to specialized filter programs like nik Multimedia's Color Efex Pro and Applied Science Fiction's Digital ROC and SHO. In addition, certain functions of the digital camera, in particular the white balance feature, can also be used to control the color characteristics of a captured image, essentially acting as a set of built-in electronic filters.

Throughout this book I have emphasized how images can be corrected technically as well as changed creatively. Many of the images are the result of both camera and computer filtration, thus demonstrating how these two tools can have a symbiotic relationship. As a professional photographer who learned his craft using manual cameras and conventional darkroom equipment, I find today's digital imaging technology nothing short of amazing. It has allowed me to explore my feelings about making photographs on levels I never thought possible. I hope this book will help the reader explore his or her own photographic aspirations and, in the end, create new ways to use photography.

Photographic Qualities of Light and the Role of Filters

All light is not the same—for that matter, neither are photographers—and that simple fact gives us all the chance to create something different.

The process of producing a photographic image, either digitally or on film, is based primarily on recording light reflected off the surface of a subject. Whether it is misty morning sunlight or light from a studio soft box, the final image will be made up primarily of this reflected light. As light travels from its source to the subject and finally to the camera, many variables can change its most basic and important qualities such as the color temperature, contrast range, and intensity. Various light sources have significantly different characteristics. All these factors can have an enormous impact on the appearance of a subject.

Traditionally, photographers have relied on camera filters to control many of these variables. In recent years, this control has been extended even further by the use of computers and software. Knowing which camera and/or digital filter method to use really begins with an understanding of the key characteristics of light sources and how the physical environment affects those characteristics. Fortunately, this understanding does not have to be on the level of a college physics course. On the contrary, it comes down to knowing just a few basic principles, as well as how and when to apply them. Thus, the journey to the final image begins by understanding how it is initially formed by light and why all light is not the same.

THE PHOTOGRAPHIC QUALITIES OF LIGHT

The easiest way to approach the relationship between light and filters is to think in terms of three key photographic qualities of light: intensity, contrast, and color content. Each of these has control over a certain aspect of the subject's appearance through its individual impact as well as by influencing the other two qualities. Filtration can significantly alter any or all of these three characteristics in subtle to very dramatic ways. Consequently, filters are categorized by how they alter the three qualities of light.

Although natural light comes from a single source—the sun—the quality of that light can be very different depending on the time of day. In this picture, the setting sun produces a decidedly warm cast on the white sides of the building. The shadow areas have a blue tint because these areas are illuminated by the reflected light from the blue sky.

Intensity

One of the most basic requirements for the photographer is to have enough light to record an image. Typically, photographers think of intensity in terms of a set of *f*/stop and shutter speed settings to make a correct exposure. Thus, a photographer will measure either the light bouncing off the surface of a subject using a reflected light meter or the light falling on a subject using an incident light meter.

Intensity is linked to the sensitivity of the digital camera sensor or the sensitivity of a film's emulsion. This relationship is represented by the ISO (International Standards Organization) rating, also called the Exposure Index (E.I.). The higher the ISO number the greater the sensitivity to light and, therefore, the less light needed to produce a proper exposure.

While filters cannot increase the intensity of light, there is a group that will reduce the light's intensity. These are the neutral-density (ND) filters, which block all wavelengths equally. One of the practical applications of this type of filter is that the photographer can then use a slower shutter speed to produce a variety of motion blur effects. For example, moving water becomes an ethereal soft blur or a speeding racecar appears as a series of colored streaks.

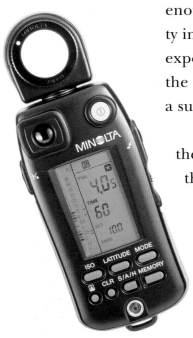

Light meters measure light intensity for the purpose of determining exposure settings. The Minolta Flash Meter VI can measure reflected light as well as incident light for both ambient light and strobes.

Contrast

As a visual concept, contrast can be described as the degree to which individual colors and/or tones in an image are different and distinct from one another. Usually, contrast is thought of as a general impression based on the range of colors or tonal differences in an image. There is also the concept of local contrast based on the difference between two colors and/or tones that border each other. Very often photographers use filters specifically to produce an increase in local contrast. For example, an enhancing filter intensifies the reds and oranges from the surrounding greens in a photo of autumn foliage. In black-and-white photography, using a red filter renders a pale blue sky with more density (to appear darker) compared to the clouds.

Contrast is controlled to a large degree by the size of a light source relative to the size of the subject. As a general rule, the smaller the light source, the greater the contrast. Conversely, the larger the source, the lower the contrast. As an illustration of this simple principle, compare the picture of the louvered door illuminated from behind by direct sunlight (left) versus the picture taken shortly after (right) when a cloud moved in front of the sun. The direct and concentrated light of the sun becomes diffused through the cloud. This same principle applies when the light of a small studio strobe is diffused by the use of a soft box. In both cases, the direct light source (the sun and a studio strobe respectively) has greater contrast than the diffused light source (the cloud and the soft box).

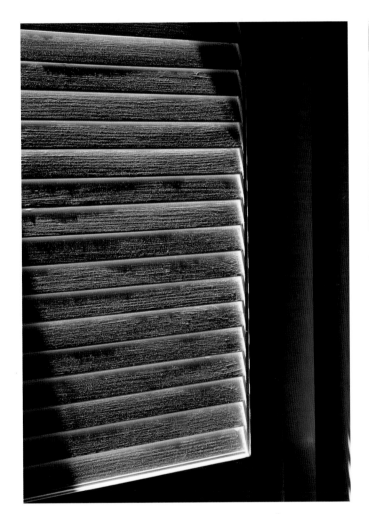 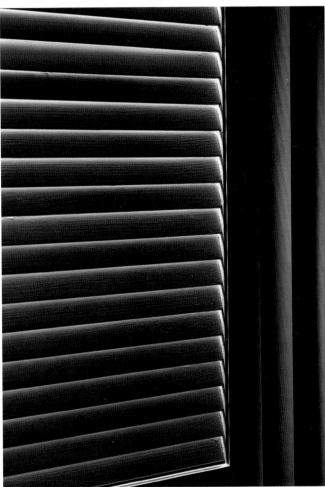

Direct light sources such as an on-camera flash or the sun on a clear day produce high contrast images with deep shadow areas and very bright highlights. Increasing the size of a light source or diffusing the light will lower the contrast. In the photo on the left, the direct light from the sun produces harsh contrast. Compare this to the softer contrast in the photo on the right in which a large cloud has moved in front of the sun. This cloud acts like a giant studio soft box to enlarge the source of light.

Black-and-white photography depends heavily on the appearance of distinct shadow areas and bright highlights to build up the illusion of image depth, as seen in the photo on the left. When the computer is used to reduce contrast, the image on the right "flattens out" and loses it's three-dimensional appearance.

Certain types of filters can significantly alter the appearance of contrast by scattering the light so that bright areas are reduced in intensity and black areas become a shade of dark gray. Typically these are classified as diffusion, mist or fog filters. Also, some of the stronger soft focus filters will scatter enough light to lower contrast. Certain diffusion filters can even produce tight halo-like patterns around bright specular highlights and point light sources. In a similar fashion, large bright areas may also appear to have a glow or outlining shimmer from certain filters in this group.

An 85B color conversion filter was used to make the gray overcast day look like a sunset in both photos to the right.

For the lower photo, a Tiffen Pro-Mist #3 was added. This filter scatters light from bright image areas to dark areas, which generally lowers the overall contrast of the scene.

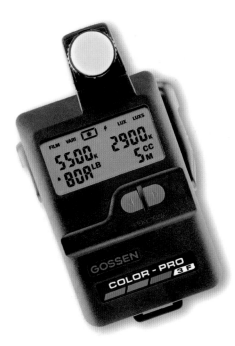

Color meters actually measure the color content of light. This meter reads the color temperature of various light sources and provides data about which filters are needed for color corrections.

Color Temperature

The most complex quality of light is its color temperature. This is determined by the proportions of the three primary wavelengths perceived by humans as the colors red, green, and blue (RGB). All other colors are formed by different combinations of RGB wavelengths, which is why they are called the "additive primaries."

Photographers will frequently describe light as being neutral, warm, or cool. That is, neutral light occurs when all three primary colors are at or near 33.3% each. Whether light is warm or cool will then depend on whether the red or blue end of the color spectrum is proportionately higher. Most artificial light sources made for photographic use have a standardized color temperature. In the case of electronic flash, there are approximately equal proportions of red, green and blue. In the case of studio tungsten lights, there is a higher proportion of warmer wavelengths to cooler wavelengths, with green holding at about 30%.

The color temperature of sunlight varies throughout the day. For most of the day, sunlight will have approximately equal proportions of RGB wavelengths. But, for those periods from about four hours after sunrise and four hours before sunset, warmer wavelengths will be in higher proportions. In addition, weather conditions such as mist, rain, clouds, and snow will change the color balance of the light. Such conditions will act like environmental filters with the most common effect being a shift in the proportions of warmer and cooler wavelengths.

The Color Composition of Light Sources

Light Source	Approximate Percentages		
	Red	Green	Blue
Household lighting (40-60 watts)	61%	32%	7%
Tungsten lighting (3,200K)	50%	30%	20%
Mid-day sun (clear day)	33%	33%	33%
Overcast/cloudy day	27%	34%	39%

Most light sources are made up of a combination of red, green, and blue wavelengths, but not all light sources have the same proportions of RGB wavelengths, as shown here. In general, it is the amount of red and blue that will vary, producing what photographers frequently refer to as "warmer" and "cooler" light.

The Kelvin Scale

Obviously, it is useful for a photographer to have some idea of the color temperature of a particular light source. The Kelvin temperature scale is used universally in photography to give an indication of the proportions of red to blue wavelengths of light. Hence, color temperature is equated with how warm, neutral, or cool a particular light source is and will give some idea of how the scene or subject will appear in a photograph.

A rating of 5,500 to 5,600K (Kelvin) effectively represents equal amounts of RGB wavelengths or white light. Temperatures less than approximately 5,500K will have proportionally more of the warmer wavelengths and higher temperatures indicate a higher proportion of the cooler wavelengths.

Camera filters can be used to alter the color temperature of a light source in very precise increments so that a photographer can change the color balance to match the film or the digital camera's white balance. For example, a blue 80A color conversion filter will block some of the warm wavelengths in tungsten light so that the RGB content will be roughly equal and appropriate for daylight-balanced film or a digital camera set for daylight capture.

Approximate Color Temperatures

Light Source	Degrees Kelvin
Candle flame	1,500 – 1,800
Sunset	2,300*
Sunrise	2,500*
40-watt household bulb	2,600
100-watt household bulb	2,900
Photographic tungsten light	3,200
Photographic light box	5,000
Moonlight	5,400
Mid-day sun	5,000 – 5,600*
Studio and camera flash	5,000 – 5,600
Overcast sky	6,000 – 8,000*
Skylight in shade areas	7,000 – 10,000*
Color TV screen	9,300
Clear blue sky	12,000 – 30,000*

*Approximate values dependent on environmental factors such as elevation compared to sea level as well as weather and other atmospheric conditions.

Photographers use the Kelvin Temperature Scale as an indication of whether a light source is neutral, warm, or cool. At about 5500K, the light is neutral. Lower temperatures are warmer and have a greater proportion of red light. Higher temperatures appear cooler and have more blue light.

THE COLOR TEMPERATURE OF PHOTOGRAPHIC LIGHTING

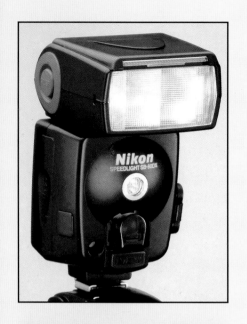

Manufacturers of photographic lighting equipment use the Kelvin scale to indicate how warm, neutral, or cool their light sources are. Electronic flash usually falls in the 5,500K-5,600K category although this figure may be slightly higher for some smaller on-camera and built-in flash units. On the other hand, tungsten bulbs used for film and video recording have standardized Kelvin temperatures of either 3,200K or 3,400K. Still photographers generally work with standardized 3,200K lighting produced by either tungsten bulbs or halogen lamps.

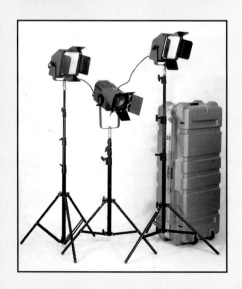

Light modifiers, such as umbrellas and soft boxes, can influence the final color temperature of light as it passes through the light modifier. It is not unusual to have aging modifiers turn slightly yellow and therefore warm the light by as much as 100 to 300 degrees Kelvin. The light modifier's fabric should be chosen carefully if you are going to make your own equipment. Materials such as white cotton sheets often have added whiteners that will tend to introduce a blue color cast.

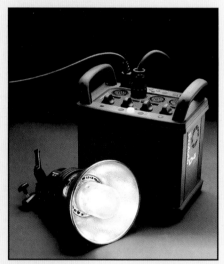

Soft boxes and other light modifiers use sheer fabric selected for its neutral coloration.

Artificial light sources for photography are manufactured within a standardized color temperature range. For example, on-camera flash units (top left) and studio strobes (center left) fall in the daylight category with color temperatures in the 5,400 to 5,600K range. Most studio "hot lights" (bottom left) are tungsten lamps or halogen lamps that generate warmer 3,200K light.

Reproduction of Color in Black and White

Each color that an observer sees and a camera records is made up of reflected wavelengths coming off the surfaces of the various parts of a scene. The light that reaches the camera in this manner has undergone a change in its color quality as compared to what it was when it began the journey from its source. This change follows a simple color subtraction principle that occurs again and again in photographic filtration; surfaces reflect on their own colors while absorbing all other colors.

For example, a red jacket appears red because the red dyes have absorbed all other colors except red, which is reflected. On the other hand, white and gray surfaces in a scene will reflect all color wavelengths equally. For this reason, pure white and gray areas are considered to be neutral. The difference between the two is that a pure white surface reflects all the light while a gray surface absorbs some of the light. The darker the shade of gray, the greater the amount of light it absorbs. A pure black surface, on the other hand, absorbs all

wavelengths equally reflecting none. Some photographers consider black to be a neutral as well, but a true pure black surface is really without any color. In summary then, the color subtractive principle can be extended to support the following conclusion; "No color reflects more light than a pure white surface or less than a pure black surface."

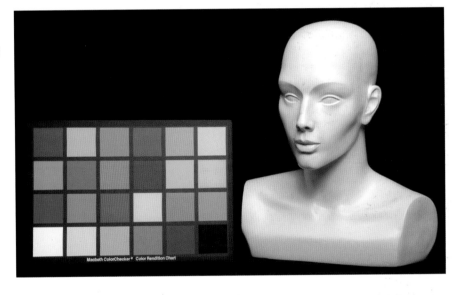

The grayscale is the basis of all black-and-white photography. The amount of light reflected off of a color will determine the tone of gray that will appear in the monochrome image. Thus, color equals tonality in black-and-white photography.

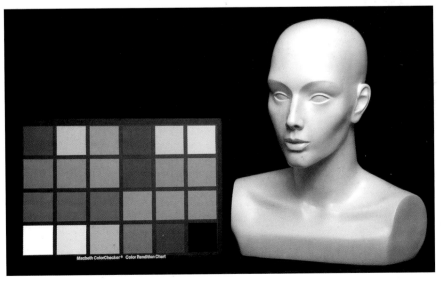

Black-and-white photographic images are made up of a grayscale of tones— black, white, and shades of gray. The amount of light reflected by each color determines its tonality in a black-and-white photograph.

COMPLEMENTARY COLORS

As pointed out, red, green, and blue are considered the primary additive colors of light. If any two of these colors are mixed in equal proportions, they will produce the subtractive primaries: cyan (C), magenta (M), and yellow (Y).

Additive Primaries	Subtractive Primary
Blue + Green=	Cyan
Red + Blue=	Magenta
Green + Red=	Yellow

A complementary relationship exists between the RGB additive primaries and the CMY subtractive primaries. This can be seen by their position directly opposite each other on a color wheel as follows: red to cyan, green to magenta, blue to yellow. These complementary relationships translate into a very simple principle for the photographer when using filters on the camera or adjusting color balance in the computer.

If you wish to block (absorb) a particular color, then use a filter that is its complement. For example, fluorescent light typically contains a green spike in its spectrum. The special fluorescent filters made by manufacturers to get rid of this color are primarily magenta (red + blue) in appearance. Another example of the complementary color relationship is the removal of the blue color cast that typically shows up in shadow areas. A warming filter with a mostly yellow component can be used to block the weak blue coloration. In black-and-white photography, a red filter can be used to really darken a clear sky because it absorbs blue light causing the sky to receive less exposure and therefore appear darker in the final image.

A color wheel graphically represents the complementary relationship of additive and subtractive primary colors.

Overcast lighting conditions will tend to produce a blue cast in photos. Often, an overcast day will also render subjects with an extremely low level of contrast. In this shot, however, there is enough local contrast separation to minimize the effect.

HOW LIGHT IS PERCEIVED

The color temperature of any light source has both a specific physical value and an interpreted quality based on the concept of color held by the observer. The physical value is the measure of the wavelengths present and can be measured in various absolute terms such as in degrees Kelvin. By contrast, the interpreted quality of color comes from our sensory system processing the light to produce the "concept" of a certain color. The absolute color range of light in the visible light spectrum extends from 400 to 700 nanometers.

When photographers use a light meter, they are measuring the intensity of all the wavelengths combined. This gives no information about the color balance of that light. To measure color temperature, a photographer must use a color meter. These specialized devices measure the amount of each wavelength of light present in a light source. Unlike the accurate measurements of a color meter, people show significant differences in the way they perceive color. Just show a series of similar red swatches to a group of people and ask each one to select the "true red." The results will surely indicate different concepts of this color.

But perhaps more important than these variations in color concept is how insensitive people can be to detecting shifts in color. For example, the color temperature of the light from the sun varies greatly throughout the day. However, most people do not pick up the subtle changes, only the dramatic sunrise and sunset color shifts. When comparing a sunny day to an overcast day, people notice the amount of light more than the specific chromatic changes taking place. Often people are surprised to see an unpleasant color cast in photographs taken under artificial light; to their eyes the light appeared white. Digital cameras and film are more absolute in terms of how they record color.

Sunsets are characteristically dominated by warm colors. In this example, the strong warm light is obvious even on the dark pavement.

Besides being a poor judge of color, human observers will often misinterpret certain visual clues as indicators of high or low contrast. An observer may, for example, interpret the darkening of a blue sky (as typically happens with a polarizing filter) as an increase in contrast since it brings a rich blue color to the image. This false interpretation of contrast, sometimes referred to as "perceived contrast," cannot be overlooked as a factor when evaluating the visual effect that a particular filter will have on a scene.

After many experiences measuring light and recording subjects in different types of light, a photographer usually builds up an appreciation of the limits of the human visual system. That is, to understand that we humans are constantly making unconscious accommodations for changes in color, brightness, and contrast. Thus, the knowledgeable photographer always makes the effort to know something about the physical characteristics of the light source present and if necessary, what filter options might be employed to either correct for a problem or to produce a particular effect.

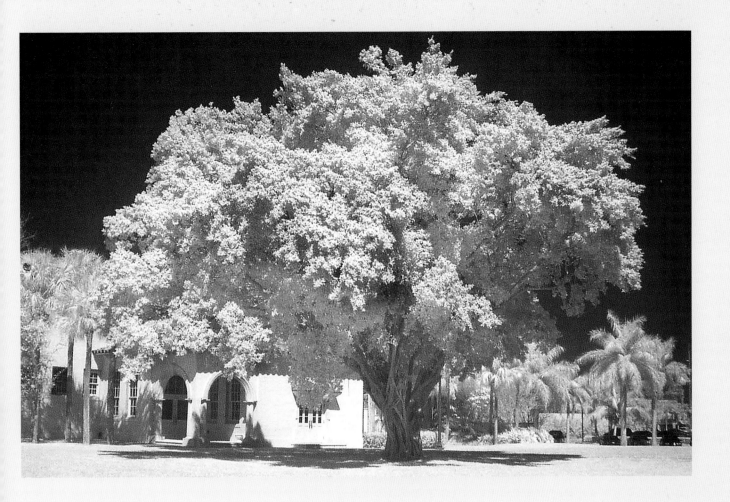

Infrared Light

If the general viewing audience is very poor at detecting shifts in specific colors, they are pretty much at a loss for knowing how most colors will translate into a specific tone in a black-and-white photograph. This is a skill that black-and-white photographers know takes quite some time to perfect. On the other hand, show someone a black-and-white infrared photograph and they are sure to see the unique way in which infrared light transforms common subjects, such as blue sky, green grass, and leafy trees. Skies reproduce as black and foliage appears white.

Infrared photography records light not visible to the human eye. Normally, this requires either special film or a digital camera that is sensitive to IR wavelengths. To record infrared light, all—or virtually all—visible light must be blocked with a very dense infrared filter.

THE MANY FORMS OF NATURAL LIGHT

Sunlight

Sunlight can occur in many forms, depending on the position of the sun in the sky and atmospheric conditions. Direct sunlight during the majority of the day is a neutral white light source. It also has a high degree of contrast and intensity as well as being very directional producing distinct shadow areas.

When direct sunlight is blocked by an object and forms shadow areas, the light takes on a cool appearance with a weak blue color cast. This is because shadow areas are primarily illuminated by sunlight reflecting off the blue sky. On an overcast day, sunlight has to penetrate a thick layer of water-laden clouds. The "gloomy" effect this produces is partly because cooler wavelengths are now dominating. The diffused light also "flattens out" contrast.

Sunrise/Sunset

At sunrise and sunset, the color proportions of sunlight shift strongly to the warm end of the spectrum. The increase in warm light when the sun is near but still above the horizon is due to the filtering action of the atmosphere. The amount of air mass that the light has to penetrate in order to be seen by an observer on earth increases enormously as the angle of the sun becomes more acute. Cooler wavelengths of light are shorter than warmer wavelengths, therefore, they experience a greater degree of scatter resulting in a greater proportion of warmer wavelengths. Thus, the atmosphere acts like a giant warming filter as the sun nears the horizon.

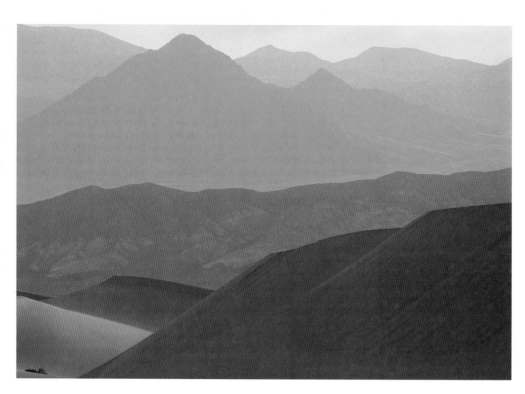

In landscape photographs, ultraviolet (UV) light can produce a hazy appearance and decreased contrast. UV filters can block UV light. Unfortunately, pollution and other atmospheric effects produce a similar look, but are unaffected by filtration.

As with sunsets, the early moments of a sunrise are dominated by warm wavelengths of light. Occasionally, just the right set of atmospheric conditions will produce a spectacular red sunrise as seen here.

top left: The warm phase of twilight occurs just after the sun dips out of sight below the horizon.

top right: As the sun retreats below the horizon, a magenta phase usually develops; the weak warm rays of the sun mix with the blue skylight.

Twilight

When the sun is just below the horizon, there is a short period of time during which a beautiful soft and moody twilight exists. Photographically speaking, there are actually three stages of color to twilight between when the sun is just out of sight below the horizon and ending with darkness. In the warm phase, the sun is closest to the horizon. The lower portions of the sky have a warm red-orange cast nearest the sun while the upper sky may remain blue. When the atmospheric conditions are just right, this warm phase can be truly spectacular. As the sun dips lower below the horizon, a magenta phase develops for a short time and then gives way to a blue phase until darkness finally replaces all color.

bottom right: Between the magenta phase of twilight and darkness, the light is a deep blue.

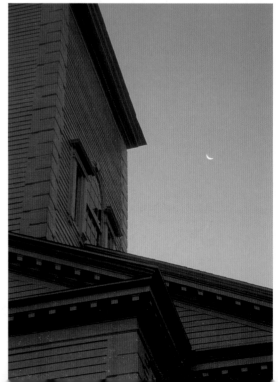

Fog, Mist, and Snow

Atmospheric conditions such as clouds, haze, fog, and smog all act like environmental filters. In general, they produce a cool color cast in the scene. Also, these conditions will lower contrast by scattering the light. While so-called Mist and Fog filters carry the names of these weather conditions, they cannot replicate the unique qualities of natural mist and fog. Basically, these filters provide a more uniform scattering of the light, which creates a general atmospheric effect to reinforce a moody rendering.

Atmospheric conditions that scatter light, such as fog, mist, and snow, will also tend to mute colors and lower the contrast of a scene.

top left: House and field in autumn morning mist
top right: Snowstorm in the city
bottom: Maine lobstermen on a foggy morning

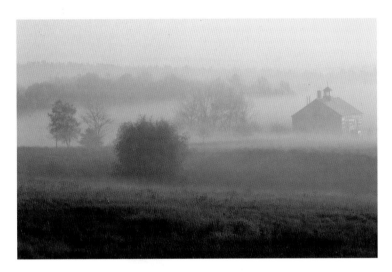

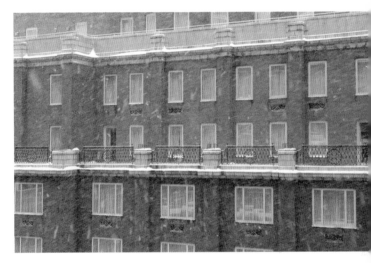

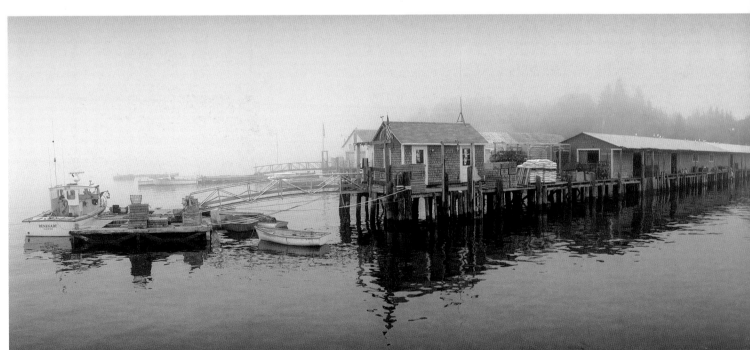

FILTER SUMMARY

Color Filters

Color Conversion: Alters the color temperature of light significantly to balance the light source and film type.

 80-series (medium blue)

 85-series (medium amber)

Light Balancing: Changes the color temperature by a few hundred degrees.

 81-series (light amber) warming filters

 82-series (light blue) cooling filters

Color Compensating (CC): Makes specific color changes with accuracy.

 Cyan, Magenta, Yellow, Red, Green, and Blue—available in a range of densities.

Specialized Color Filters

Sepia: Produces the yellow-brown look of a bygone era

Warm Enhancing*: Intensifies red, orange, and yellow.

Fluorescent: Blocks the green in fluorescent lighting

 *There are also Blue and Green enhancing filters.

Non-Colored Filters

Polarizer: Reduces reflections, darkens clear blue skies areas

Neutral Density: Blocks all wavelengths of light evenly, reduces intensity of light

Soft Focus: Depending on the specific filter, can reduce sharpness and/or contrast

Fog and Mist: Mimics the soft qualities of fog and mist

Filtering Techniques for Natural Light

Even in bright sunlight, a scene can have a cooler coloration in the areas that are in shade. The traditional filter choice to reduce or remove the blue cast in shadow areas is a pink skylight filter or a weak 81-series warming filter, such as the 81A. In snowy or foggy conditions or on an overcast day, the choices for filtration are similar to those for shade; enhance the scene with warming filters. In all these cases, skylight and warming filters can lower the high color temperature of the light to a more neutral or slightly warm look.

While filters can effectively alter light conditions, there are limitations. For example, once the sun is close to the horizon, the color spectrum is almost devoid of blue wavelengths of light. Thus, it is not really practical to try and neutralize or equalize the natural light with strong filters. There simply is not enough blue light. The same is true of the blue twilight period when blue is the dominant wavelength and there is very little if any warm light with which to work.

On the other hand, if you wish to remove some of the excessive warmth of late afternoon sunlight, this can be done using one of the weaker, blue 82-series light balancing filters. Still another filter application is the "blue water effect" that can be used when photographing large bodies of water during a sunset or sunrise. Typically, lakes, rivers, and seas have a decided look of red wine or as Homer referred to it in the *Odyssey*, "the wine-dark sea." Using a stronger 82-series filter such as the 82C or any of the blue 80-series color conversion filters will give the water a more blue appearance. The blue coloration will not, however, show up in the sky of a sunset or sunrise because of the overpowering effect of the warm sun near the horizon. Bodies of water, on the other hand, are illuminated in part by light reflected off the sky and will respond to blue filtration.

Both the magenta and warm phases of twilight can be extended and/or enhanced with filters. For the warm phase, a stronger warm light balancing filter like an 81C or 81EF, an 85-series color conversion filter or an enhancing filter will all contribute to the coloration. For the magenta phase, a weak magenta color compensating filter is so effective that some photographers refer to it as the "twilight filter." In addition, any of the specialized fluorescent filters, such as the FL-D or FL-B, will mimic or increase the look of this red-blue phase because they have a magenta coloration.

ARTIFICIAL LIGHTING

Household Tungsten Lighting

The problem with household light bulbs is that they are not as tightly standardized as photographic tungsten bulbs or halogen lamps. Thus, the color temperature of household bulbs can vary due to age, tinted glass, etc. Such variations require a color meter to obtain an accurate measurement. In general, as the wattage of the bulb decreases, so does the temperature of the light.

If the film or the camera's white balance is for daylight, the low color temperature of household lighting will render a subject with an overall warm cast. For this image, the digital camera's auto white balance setting was used to correct for the lighting. Even so, additional adjustments are needed.

Fluorescent Lighting

Fluorescent tubes present a different kind of problem. While these light sources are rated as warm and cool with specific temperature ratings, they also have an excessive amount of green. The result is a warm or cool looking light that also has a noticeable green cast.

The best way to correct for fluorescent lighting is to use the recommended filtration from the tube manufacturer. Unfortunately, even this may not work if the scene has tubes made by different manufacturers. More often, photographers are making the best filter or digital white balance correction they can when shooting and then using software to make the final correction. Consequently, it is a good idea to include a white card or gray card in a test shot and work to neutralize these in the computer to determine the color correction needed for the other images.

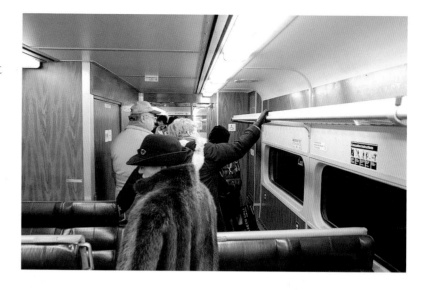

In this picture of homeward bound train commuters, the green cast from the fluorescent lighting is evident. The picture was taken with a digital SLR camera set for daylight capture.

Theatrical and Commercial Lighting

There are also a number of other "non-standard" tungsten light sources that may be encountered in photography. Normally, the lights used in stage productions fall somewhere around 3,000K, depending on the age of the bulbs. The use of strong gels over stage lights will completely change the color of the light. For example, a night scene on stage may have an all-blue wash of light.

Most large outdoor spaces and indoor arenas are illuminated with discontinuous spectrum lighting. That is, the lights do not have a full RGB spectrum. Mercury vapor lighting has greatly reduced blue and red wavelengths and sodium vapor has very little blue or green. A full neutralization of this type of lighting is very difficult with camera filters. Even a digital camera's auto white balance function will have trouble obtaining a correct rendering of the colors.

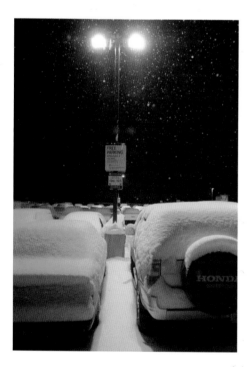

Outdoor areas such as parking lots are often illuminated using discontinuous spectrum lighting. These types of lights usually have a predominant "spike" of a certain color. With sodium vapor, a spike of red and yellow gives images a warm color cast.

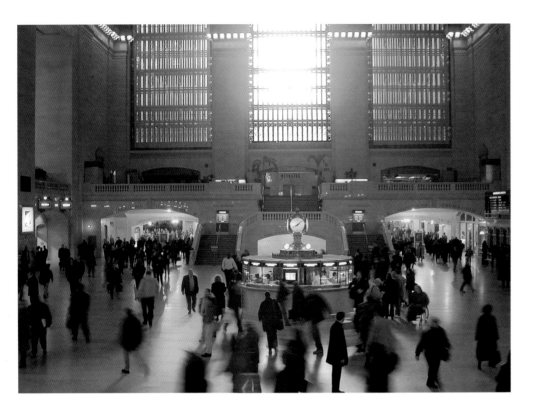

Rendering color accurately is most difficult when there are multiple light sources, as seen here in New York's Grand Central Station. The predominant light source was daylight. Fluorescent lighting and various tungsten sources combined to produce different color casts throughout the scene.

Mixed Lighting

Last but certainly not least are the problems associated with mixed lighting, for example, an office setting with both tungsten and fluorescent lighting. In the interior shot of New York's Grand Central Station, the digital camera was set for daylight capture since this source was dominate coming through the huge windows. Thus, the remaining interior tungsten and fluorescent lights produced definite color shifts in their respective areas. In general, when faced with mixed lighting, the camera or film should be balanced for the main or dominant light source.

THE IMPORTANCE OF NEUTRAL AREAS

When the RGB proportions are equal, light is considered neutral and referred to as "white light." If such a light were directed at a pure white wall, it would appear white to a human observer. It would also be recorded as white by a digital camera or by film that was balanced for that type of light. If, however, the proportions of red in the light source were to increase, the wall would take on a warm cast. By the same token, increasing the proportion of blue light would produce a cool result. Actually, the wall could be made to appear any color by changing the proportions of the individual RGB components. Needless to say, the white wall could also be made to appear just about any color through the use of colored filters because they block some wavelengths of light while allowing others to pass.

In general, people will tend to pick up the appearance of a color cast in neutral white and gray areas before noticing them in colored areas. This is something to remember when color correcting an image in the computer. Apparently, human beings are better able to detect the introduction of a color into a neutral white or gray field rather than detect whether or not a specific color is correctly rendered in a photograph. Undoubtedly, a contributing factor to this is that the pure colors on test charts are not found in the environment. On the contrary, colors in the scenes we want to photograph are usually mixtures. Thus, most of us do not have consistent experiences with an absolute standard for color. On the other hand, introducing color into a neutral area is more likely to be noticed. As will be demonstrated in Chapter 4, "cleaning up" a color cast in neutral areas is an effective way to produce a color-corrected image.

Color Casts—Where Do They Come From?

There are two main reasons for a color cast to appear in a photograph: (1) an imbalance between the color content of the light and the recording media and (2) color reflected onto an object from another surface.

Stronger color casts will appear when the color content of a light source does not match the color sensitivity of the film or the digital camera's white balance setting. For example, using daylight film or a digital camera set for daylight balance to photograph under household tungsten lighting will produce a photo with a warm orange cast. The temperature difference between the light source and the recording media could be as much as 2,500K. In

White areas frequently pick up a color cast from light bouncing off a colored surface. In this photo, the shadow areas, which should be a neutral gray tone, have a slight green tint. This is because these areas are illuminated by light reflected off the green marble floor.

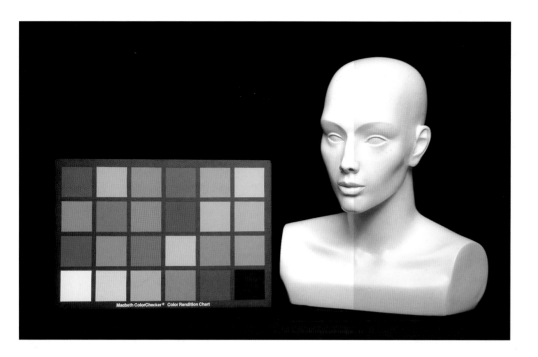

In this photo, light was reflected off of blue panels positioned on either side of the still life. Half of the mannequin was color corrected with the computer for comparison. The blue cast is clearly visible on the surface of the mannequin and in the lighter shades of the gray scale. It is difficult to detect any significant shift in the colors of the chart.

addition, this color contamination will significantly alter the appearance of all colors, not only the neutral areas. Knowing the color temperature of a light source and the camera filters or color corrections to use for different light sources are really basic things that every photographer should know.

The second—and usually more subtle—type of color contamination occurs when light passes through or reflects off of a strongly colored object before reaching the subject. For example, window light filtered through sheer blue curtains will appear blue and a bride's white dress might have a green cast if there is a green wall nearby. Photographers will often say that the light has "picked up a color." Actually, the color cast is caused by a shift in the proportions of RGB wavelengths due to the color subtraction principle. No color was picked up—instead, some wavelengths of light were lost which increases the proportions of the remaining colors in the light. So, a set of sheer blue curtains will blocked some of the warmer colors while allowing blue light to pass.

Studio photographers are most able to control the intrusion of a color cast by either not having large colored surfaces in the studio in the first place or by blocking such contaminated light with large black panels or gobos placed around the subject. Those who have to work on location, such as wedding and event photographers, usually cannot employ such controls. Here, the problem of a color cast can be dealt with by the use of a weak filter in a complementary color that will absorb some or all of the errant color. But as with most corrective applications, the photographer has to first recognize a situation in which color contamination could occur.

2 An Overview of Camera Filters

We see life filtered through a mind full of experiences that cannot but color our thoughts.

As pointed out in Chapter 1, one of the best ways to understand the function of a filter is in terms of how it is used to change the basic qualities of light. Consequently, this chapter follows that theme by dividing filters according to their primary effect on the qualities of light, beginning with color content followed by contrast and then intensity. In addition, this chapter briefly considers the advantages and disadvantages of the various filter designs for use with today's digital and film cameras, concluding with tips on caring for and maintaining filters. We will begin by first looking at filter nomenclature and filter factors.

FILTER DESIGNATIONS

Filter Names

A photographer beginning to use camera filters is faced with a multitude of choices and an array of competing filter designs. Because there is no single universally accepted convention for naming filters, the reader will likely come across different designations among various brands. The names of filters and filter categories that appear throughout this book are the common designations used in North America.

In addition to common designations, most manufacturers have custom filters with proprietary names. For example, the Tiffen 812 light-balancing filter is a proprietary filter with a unique warming effect slightly different from standard 81-series warming filters. Other examples include various custom combinations, such as Cokin's Polacolor Red and Polacolor Blue colored polarizing filters.

Names and categories aside, some variations occur between filters of the same designation that are manufactured by different companies. The 81-series warming filters are known for differences in color between brands and photographers often favor one brand over another. In general, there is an overall consistency between manufacturers for the most commonly used filters.

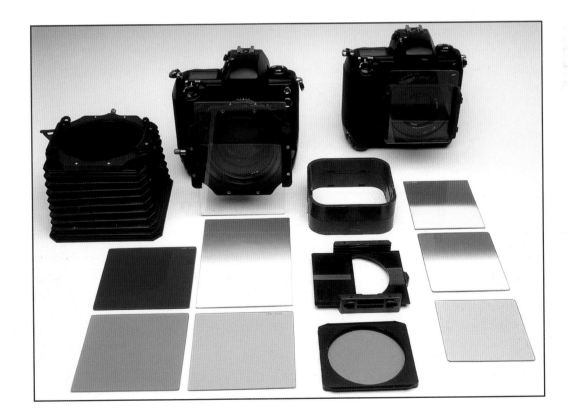

Bracket mount filters allow for special accessories such as lens hoods and holders for gel filters. Most photographers will have a selection of both round and bracket mount filters and may even use them together.

Filter Grades

Some filters are available in varying grades, which represent different strengths depending on the density of the filter material. Stronger or weaker filter grades are usually indicated by the use of a number or a letter after the filter designation. In general, filters with a higher numeric designation (#1, #2, #3, etc.) have a stronger effect. For example, the Nikon Soft #1 has a weaker soft-focus effect than the Nikon Soft #2. The letter designations are not as clear-cut. With the 82-series of light-balancing filters, the 82A is weaker than the 82B, which is weaker than the 82C. However, the 85-series filters do not follow the same logical progression (see chart on page 40). The strength of the filters will be noted as each group is reviewed.

Filter Factors

Because colored and neutral-density filters as well as certain other filter designs will block some light from reaching the film or the sensor of a digital camera, a standardized measurement called the "filter factor" is used to indicate how much light is lost. As the following figures indicate, the higher the filter factor, the greater the light loss and the greater the exposure adjustment must be to compensate.

Does the photographer have to calculate the filter factor and figure the exposure adjustment or will the meter do this automatically? The light meter in most film and digital cameras will give accurate readings with the filter in place. If the camera is in automatic or program exposure mode, it will then set the correct exposure automatically. With manual exposure mode, the photographer can use the f/stop and shutter speed recommended by the meter. There are some exceptions, especially among the stronger colored filters, which will be covered in the section on colored filters.

Filter Factor	Light Loss (in stops)
2X	-1
4X	-2
8x	-3

Some filters have factors that fall between these whole numbers. The literature that comes with each filter should provide the exact filter factor.

The best approach here is for the photographer to test any new filter with the camera being used. For example, take meter readings with and without the filter in place. Compare the actual loss of light registered by the meter with the filter factor. If the meter does not correctly compensate for the filter, then meter the scene without the filter and manually set the exposure to account for the filter. Obviously, the user should avoid using automatic or program type exposure modes with filters whose factor cannot be read accurately by the camera's meter.

In addition to filter factors, some filter effects will be dependent on the *f*/stop used. For example, certain portrait filters will vary in intensity depending on the aperture setting. The effect of graduated filters can also be altered somewhat by aperture settings. Extremely wide aperture openings such as *f*/1.4 or *f*/1.8 have less depth of field that produces a slightly softer line of demarcation at that point where the graduated effect ends and the clear portion of the filter begins. On the other hand, stopping a lens down to *f*/22 or *f*/32 may make the point of demarcation slightly more pronounced. It should also be noted that the effect of a polarizing filter and its effective filter factor will vary depending on how the filter's rotating ring is set.

Graduated Filters

The most common filter design is the homogenous type that uniformly applies an effect across the entire image area. Alternatively, there are designs that have only a portion of the filter material coated to produce an effect; examples include graduated, center-spot, and center neutral density filters. In recent years, filter manufacturers have become quite imaginative at coming up with new designs and configurations. As a result, today's photographer can select from the widest range of custom filter designs that have ever been available.

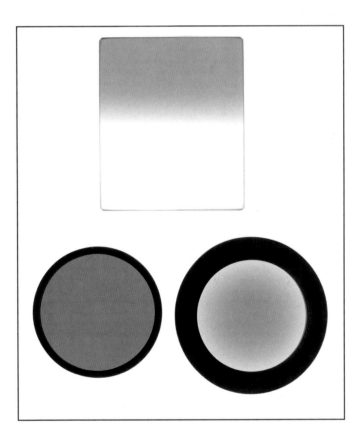

Three of the configurations for colored and neutral density filters are shown above. The solid or uniform type (bottom left) distributes the filter material evenly. The graduated design (top) has the material applied over only a portion of the filter. The center neutral density design (bottom left) applies the material over the center of the filter to counter fall off with wide angle lenses.

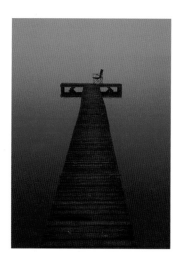

The effects of colored filters can vary widely—they offer so many options for enhancing or even creating a mood in a photograph.

FILTERS THAT ALTER THE COLOR OF LIGHT

A wide range of colored camera filters can alter the color of light. The mechanism for this change in the case of all these filters follows the principle of color subtraction covered in Chapter 1. That is, the filter's color(s) are allowed to pass through while all others are absorbed. The degree of absorption of the complementary colors will depend on the strength (density) of the filter. Consequently, weaker filters will only hold back a smaller portion of light in a scene. This will result in only a slight change in the overall color cast of the final image. The effect produced by the stronger filters is much more dramatic.

COLOR FILTER CATEGORIES

The main classes of colored filters will be considered here in detail. Since color is the most complex of light's qualities, it is not surprising that the number of colored filters available to produce changes in the chromatic make-up of light is extensive.

Color Conversion Filters

This category consists of the blue 80-series and amber 85-series filters. Both are used to convert the color temperature of light to match a particular film balance or a specific white balance setting for a digital camera. The blue 80-series filters are actually a mixture of cyan and magenta coloration while the amber 85-series filters are a combination of yellow and magenta. Thus, the blue 80-series raises the color temperature by blocking warmer wavelengths while the amber 85-series lowers the color temperature by blocking the cooler wavelengths.

The most commonly used color conversion filters are: the 85B for shooting in daylight with tungsten film or a digital camera set for tungsten light and the 80A for shooting in tungsten light with daylight-balanced film or a digital camera set for daylight capture.

Creative Uses for Color Conversion Filters

In addition to its corrective role, the 85B filter is also useful for mimicking the warmth of a sunset or prolonging the warm phase of twilight as well as evoking an atmosphere of heat as in a desert setting. It might be thought of as an extreme warming filter and can therefore be employed whenever this effect is desired.

The 80A, on the other hand, can enhance the blue in a sky that is turning blue-black as darkness approaches or convert an overcast gray day into a "blue mood." This blue mood will be more pronounced if an 80A filter is used with a digital camera set for tungsten-light balance. This filter will also render the ocean or a lake as blue at sunset when these bodies of water typically take on a reddish cast. The areas of sky near the setting sun will remain red-orange but the upper sky will take on a more intense blue. The 80A is also effective at giving a metallic blue color cast to unpainted metal surfaces, such as a large building made of steel and glass.

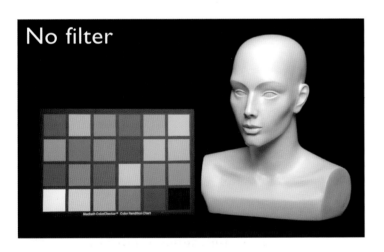

No filter

The relative strengths and color changes of color conversion filters can be seen in these images taken with a digital SLR. A studio strobe light with a soft box was used with the camera's white balance set for flash.

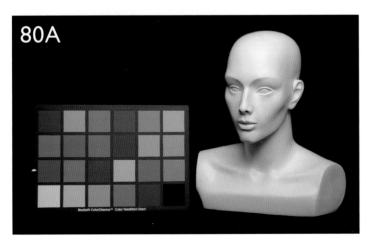

80A

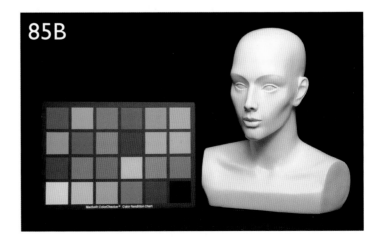

85B

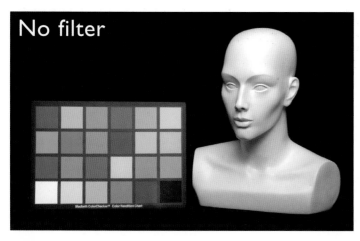

No filter

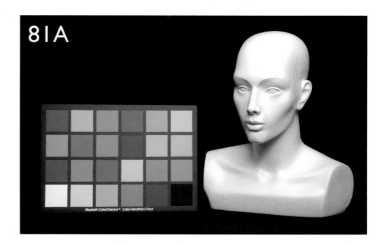

81A

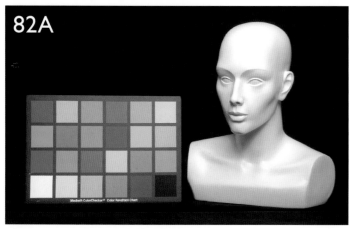

82A

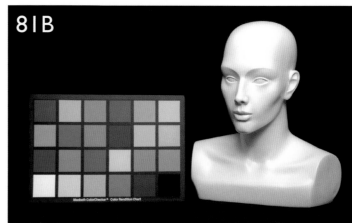

81B

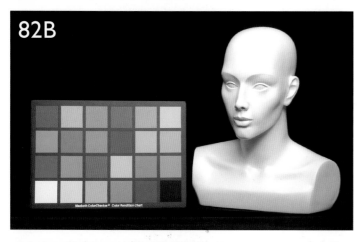

82B

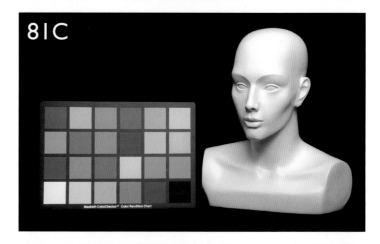

81C

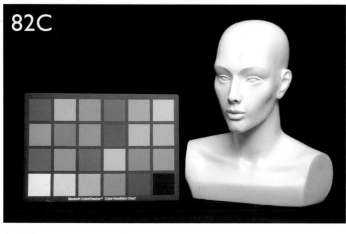

82C

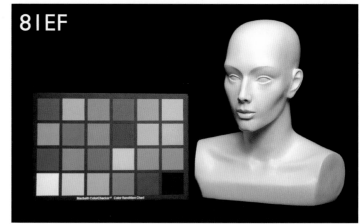

81EF

on the opposite page:
The relative strengths and color changes of light balancing filters are shown in these images taken with a digital SLR. A studio strobe with a soft box was used with the camera's white balance set for flash.

right:
Proprietary warming filters, such as the Tiffen 812, produce an effect that is similar to a weak 81-series light balancing filter.

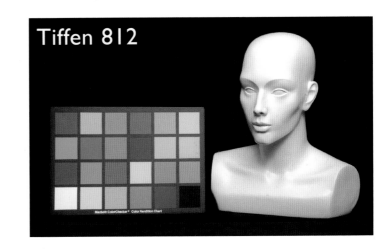

Light Balancing Filters

The light blue 82-series filters and light amber 81-series filters are basically weaker versions of the color conversion filters. They increase or decrease the color temperature of light in smaller increments. Light balancing filters shift the color temperature a few hundred degrees as opposed to the color conversion filters that change the temperature by several thousand degrees. The 82-series filters are often called "cooling" filters because they make a scene appear more blue. (They actually increase the color temperature of the light.) Conversely, the 81-series filters are known as "warming" filters. The A, B, C letter designation after the filter number indicates an increase in density and therefore a more prominent effect.

Creative Uses for Light Balancing Filters

By far, the most popular light balancing filters are the 81-series, in particular, the 81A for its gentle warming effect on people portraits and natural settings. In addition, the 81-series filters are useful for removing or reducing the blue color cast in shade. The stronger 81-series filters are the ones to select for giving a warm appearance to people on very gloomy days. Conversely, some photographers like to use the 82-series to purposely give a cool look to snow scenes or gray overcast days.

Because light balancing filters are rather weak in density, creative effects are best applied when photographing with transparency film or a digital camera. Color negative film will also record these subtle changes, but, unless the photographer makes arrangements with the lab, the filter effects may be removed by the print processor's automatic color correction. If you are using a professional lab, try including a gray card in the first frame with the filter in place. The lab can then accurately measure the amount of warming and include it in all prints. If you are scanning your own negatives, care must be taken to retain the filter effect when making color adjustments to the scan's preview image.

left: Cooling filters
top row: 82A, 82B
center row: 82C
bottom row: 80A

right: Warming filters
top row: 81A, 81B
center row: 81C
bottom row: 85B, 81EF

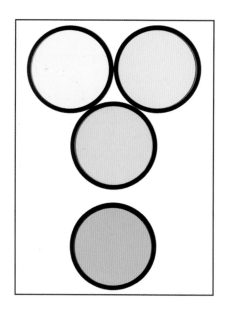
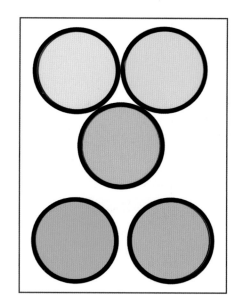

Color Conversion Filters

	Filter Designation	Light Loss*	Change in Color Temperature (From → To)
Blue	80A	2.0 stops	3200K to 5500K
	80B	1.5 stops	3400K to 5500K
	80C	1.0 stop	3800K to 5500K
	80D	2/3 stop	4200K to 5500K
Amber	85A	1.5 stop	5500K to 3400K
	85B	1.5 stop	5500K to 3200K
	85C	2/3 stop	5500K to 3800K

Light Balancing Filters

	Filter Designation	Light Loss*	Change in Color Temperature (From → To)
Blue	82	1/3 stop	3100K to 3200K
	82A	1/3 stop	3000K to 3200K
	82B	2/3 stop	2900K to 3200K
	82C	2/3 stop	2800K to 3200K
Amber	81	1/3 stop	3300K to 3200K
	81A	1/3 stop	3400K to 3200K
	81B	1/3 stop	3500K to 3200K
	81C	1/3 stop	3600K to 3200K
	81D	2/3 stop	3700K to 3200K
	81EF	2/3 stop	3850K to 3200K

*Actual light loss may vary among brands and in different shooting conditions.

Color Compensating Filters

Color Compensating (CC) filters come in the primary additive and subtractive colors of red, green, blue, cyan, magenta, and yellow. These filters are available in a range of densities that increase in small increments. The color and strength of a color compensating filter is identified by the common shorthand sequence of CC/Density/Color. For example, CC10Y indicates a yellow color compensating filter of 0.10 density while a CC40M indicates magenta filter with a 0.40 density. A higher density number indicates a stronger filter effect. Color compensating filters are used when there is a need to increase or decrease the presence of a color in a controlled way. For example, various combinations of CC filters are used to color correct for fluorescent lighting and can be some help in improving the color imbalance of sodium-vapor and mercury-vapor light sources. Typical creative uses for CC filters included boosting certain colors in a photograph to give an impression or a mood. For example, using a magenta CC filter can enhance a twilight setting.

Color Compensating or CC filters come in the primary additive and subtractive colors: red, green, blue, cyan, magenta, and yellow. These filters, especially gels, are available in a wide range of incremental densities, as seen in the example of the six yellow gels that range in density from 0.5 to 50.

Color Compensating Filter Effects

Filter Color	Colors Reduced	Colors Enhanced
Red	Blue and Green	Red
Green	Blue and Red	Green
Blue	Red and Green	Blue
Cyan	Red	Cyan
Magenta	Green	Magenta
Yellow	Blue	Yellow

Graduated filters come in a wide variety of colors and designs. The most common type has a single color with variations in the feathered demarcation between colored and clear areas. The sunset filter (bottom row, center) covers the whole filter with two different densities of the same color. The stripe filter (far right) limits the colored material to a stripe in the center of the filter.

Graduated and Stripe Filters

Graduated colored filters have become very popular in recent years with a wide selection offered by several manufacturers. They produce selective changes in the color of light following the same principle of subtractive filtration. The difference being that only a portion of the scene is affected. Unfortunately, there are no standards for color content, strength, or design in this category and custom names abound. Thus, each brand has to be considered more or less unique.

Originally, graduated filters were available as circular designs with the graduation occurring as either a soft edge between the clear section and the active filter section or as a sharply defined edge sometimes called a hard-edge graduated filter. In either case, the inability to raise or lower a circular filter in front of the lens for different placement in the picture really limits its uses. On the other hand, some photographers have found that these round graduated filters work reasonably well with non-SLR digital cameras.

Far more popular are the rectangular graduated filters that are held in a bracket holder. Rectangular filters come in three basic styles. The most common are the one-half graduated in which the color covers only half of the filter feathering off into the clear half. Different brands will have slightly different levels of feathering in the border area. Another style is a graduated filter with two different densities of the same color covering the entire filter. For example, the so-called "sunset graduated filter" has a stronger upper field of warm color density for the sky area feathering into a weaker density lower field for the foreground. The coloration here closely resembles the 85-series color conversion filters. Still another variation is to have one color in the upper half and another color in the lower half.

Related to the graduated filter are the so-called "stripe" filters. These have a stripe of color measuring an inch or so across the middle of the field with feathering on the top and bottom edges. This allows the placement of a colored strip along an area, such as just above the horizon in a landscape picture.

Enhancing Filters

In recent years, photographers have been able to buy enhancing filters to intensify specific colors in a scene. The original and most popular is the red or warm enhancing filter, but green and blue enhancing filters are also available. In general, these unique filters are supposed to alter only their designated color family and not affect other colors. While enhancing filters do target specific colors, they can also can mute complementary colors and add color to neutral areas. Enhancing filters are inappropriate for scenes that have prominent neutral areas, especially if those areas are weakly illuminated. When the goal is to generally enhance the warmth or coolness of a scene, use a light balancing filter instead. In a sprawling richly colored fall landscape, a red enhancing filter can produce a dramatic effect. Reds, oranges, and browns are predominate colors in this type of scene, so color contamination is usually not apparent.

Day for Night Filter

A little known filter that I have found to be occasionally useful is the day for night filter. This deep blue filter will transform a daylight or an early evening scene into what appears to be a nighttime setting.

Fluorescent Filters

As noted in Chapter 1, fluorescent lighting has a pronounced green content. To reduce this requires the complement to green—a magenta filter. Thus, many photographers will use a CC 20 or 30 magenta filter with good results. There are also special fluorescent filters for use with daylight (FL-D filter) or tungsten (FL-B filter) balanced film and digital camera settings. These are based on a magenta coloring but also have additional color elements to produce a better color balance.

top left: Warm enhancing filter
top right: Day for night Filter
bottom left: Daylight fluorescent (FL-D)
bottom right: Tungsten fluorescent (FL-B)

It must be pointed out, however, that there is a lot of color variation among fluorescent tubes and different films render fluorescent light differently. Accurate color correction is only possible by using the film or bulb manufacturer's specific filtration recommendations. Just to give one example, General Electric recommends the use of a CC 20 Cyan + a CC 10 Magenta with their Cool White Deluxe Fluorescent tubes when using Kodak Ektachrome films.

Sepia Filters

These filters are intended to give colored images the look of a "bygone era" by muting colors and introducing a brownish-orange coloration reminiscent of old sepia-toned, black-and-white photographs. Depending on the manufacturer, sepia filters are available in different strengths and may have a soft focus effect incorporated as well.

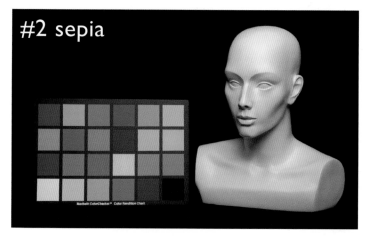

Sepia filters are intended to give color images the look of a "bygone era" by muting colors and introducing a strong warm coloration reminiscent of old sepia-toned, black-and-white photographs. Sepia filters are available in different strengths and may incorporate a soft-focus effect. The #3 sepia filter has the same color saturation as the #2 filter, but with an added soft effect.

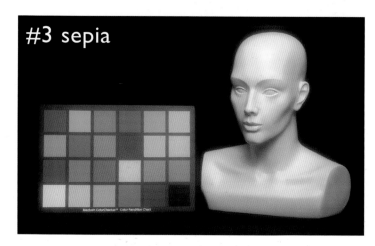

NON-CHROMATIC FILTERS

The second main category of filters are those designed to alter light not by the selective altering of color, but by other means.

Neutral Density Filters

The most common way to decrease the intensity of light is to employ a neutral density or ND filter. These filters use a neutral gray material to block all wavelengths of visible light uniformly. This design is based on the principle pointed out in Chapter 1 in which a gray area will absorb all wavelengths equally; the darker the shade of gray, the greater the absorption. ND filters come in three configurations: uniform, graduated and center spot. The designation of each filter indicates how the light is blocked.

Uniform ND filters are used to reduce the total amount of light uniformly across the entire area of a scene. This gives the photographer additional control over exposure beyond the camera's shutter speed settings and the aperture.

The graduated ND filter, has neutral density material across only half of the filter; it then ends in either a soft-feathered edge or in a sharp demarcation. ND grads will reduce contrast by holding back some of the light in bright areas of a scene, such as in the sky area above a landscape. While reducing the amount of light in sky areas is the most common use of graduated ND filters, they can also be applied to other areas of a scene. For example, when placed to cover the lower half of the frame, a graduated neutral density filter can reduce the bright reflections off of a lake. A rectangular bracket-mounted graduated filter gives the photographer flexibility to adjust where the graduated area falls in a scene.

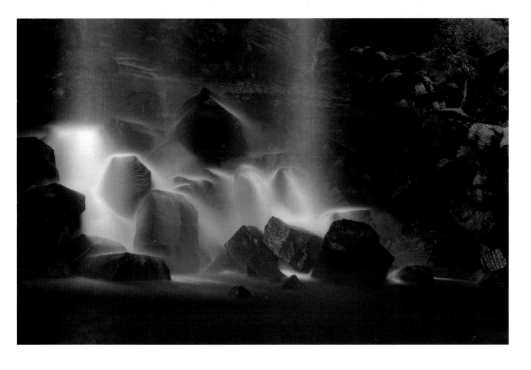

Amazing things happen when a photographer sets a slow shutter speed to capture a moving subject. Falling water takes on the appearance of angel hair as it blurs. This two minute exposure required a 0.9 neutral density filter.

A slow shutter speed can enhance the appearance that the subject is in motion. Folk dancers are reduced to a blur as they move in a circular pattern around the stationary musicians. The digital camera was steadied on a railing with a beanbag support. The two-second exposure required a 0.3 neutral density filter to block one stop of light.

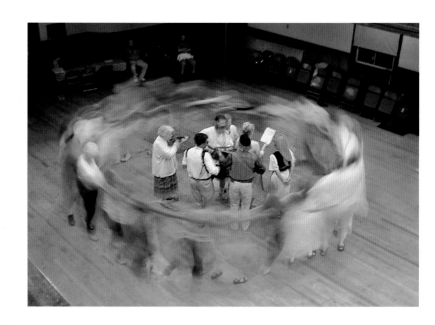

ND (Neutral Density) Filters

ND Filter	Light Loss	Filter Factor
0.3	1 stop	2X
0.6	2 stops	4X
0.9	3 stops	8X

The specialized ND center-spot filter is the least common configuration. It is intended for use with wide-angle lenses that experience significant light falloff at the edges. This is a common problem with wide lenses on non-rotating panoramic cameras and large format cameras as well as with certain wide-angle lenses in the 35mm format. By holding back a certain amount of light in the center of the picture, the exposure across the whole lens field becomes more uniform.

When metering with either a graduated ND or color filter, especially one with a strong effect, some consideration has to be given to how the filter is affecting the exposure. For example, when using a graduated ND filter to lower the brightness of a sky area, the exposure should be based on the foreground area. Either set exposure for the non-filtered area of the scene and then put the filter in position, or use matrix metering with the filter in place. The quickest way to tell if there is going to be an exposure problem is to compare meter readings with and without the filter. The desired effect in each photograph may be different, therefore, exposure should be considered on a shot-by-shot basis.

Polarizers

The polarizing filter is another form of light blocking filter, but one with a very unique mechanism. Its function is based on the fact that light will reflect in a polarized pattern off of smooth surfaces. The crystal structure of the polarizing filter is able to prevent a portion of this light from getting through. Turning the filter's outer ring controls the light absorption and therefore varies the polarizing effect. Some surfaces do not produce polarized light patterns and therefore the polarizing filter will not be able to block the glare. Shiny metal, such as jewelry or the chrome bumper of a car, is not affected by a polarizer.

Probably the most common use of the polarizer is to darken clear blue skies in both color and monochrome photography. This effect (like the glare reduction) can be seen in the viewfinder of an SLR or with the filter held up to your eye. In a pinch, the polarizer can even act as a variable ND filter by adjusting the outer ring to block up to two stops of light. For all these reasons, a polarizer is possibly the most useful single filter that is available to photographers.

The key to using a polarizer effectively is to understand that it must be at a certain angle to the light source to produce its effects. A polarizer can remove a substantial amount of glare provided the camera is positioned at the proper angle. In order to maximize the filter's results and minimize reflections, the photographer needs to place the camera at a 30-degree angle relative to the light source.

When using it to darken a blue sky, only a portion of the sky will be affected. The effected area can be determined by first pointing the index finger toward the sun and then raising the thumb to form a right angle to the index finger. Now, with the index finger still pointed at the sun, the hand is rotated left to right so that the thumb cuts an arc in the sky. This arc will represent the maximum area of effect decreasing to no effect in areas closer to the sun. One of the problems with this uneven effect is that with a wide-angle lens, the sky will appear to have a graduated field from a weak blue to a strong blue. Also, do not hesitate to use a polarizer on the sky just before sunrise or just after sunset. There will still be an increase in sky density even through the sun is not present.

Polarizing filters are also very useful at removing glare when using a copy stand. Maximum control of glare is best achieved with a process known as "cross polarization." In this approach, polarizing filters are used on the camera lens and in front of the copy lights. As with all copy work, the film plane should be parallel to the surface of the object being photographed. The angle of the lights should be at approximately 45 degrees. The polarizing filters on the camera and the lights are then rotated until glare is minimized.

Several manufacturers now offer polarizing filters with the addition of color. The effects can vary, from adding small golden highlights to an over-all strong coloration such as a dominant magenta or blue cast. Another more common variation is the warm polarizer, which adds an 81A warming filter to a polarizer, giving the effect of two filters in one.

top row: Circular polarizer, Warm circular polarizer
center row: Linear polarizer
bottom row: Bracket mount circular polarizer

Circular vs. Linear Polarizers

There are two types of polarizing filters. The linear style is limited for use with manual focus cameras since it can interfere with the autofocus and/or metering mechanisms of modern cameras. The circular polarizer is recommended for use with autofocus cameras. (Circular does not refer to the filter shape, but to the way it alters the light.) For use with digital cameras, choose a circular polarizer.

UV, Haze, and Skylight Filters

Ultraviolet or UV filters are designed to block the image-degrading effects of UV light. This type of light, invisible to the human sensory system, usually results in a loss of contrast characterized as slight to moderate haze in distant landscapes. Bear in mind that these filters are intended for reducing UV light. They do not work in other atmospheric conditions such as fog, which is tiny water droplets, and smog, which is composed of suspended contaminants. UV filters come in different strengths with the weaker versions using UV blocking materials. The stronger filters, such as the H2A, also include some color to increase the effect, but their slight color cast may be evident in photographs.

One effect produced by diffusion filters is contrast reduction. This dramatic scattering of light was created with a Tiffen Pro-Mist filter for a portrait of Maine painter, Dave Orrell.

The skylight filter is a variation of the UV filter design. It is basically a UV filter with a very weak pink coloring intended to warm up shade areas that tend to have a weak blue cast from reflected skylight. Most UV and skylight filters have negligible filter factors so that no adjustment in exposure is necessary. Some photographers like to keep either a UV or skylight filter in place all the time to protect the front element of the lens.

FILTERS THAT ALTER CONTRAST AND/OR SHARPNESS

Soft Focus, Diffusion, Fog, and Mist Filters

All the various filters that alter the contrast and/or sharpness of an image form the largest and most diverse collection. Among the many descriptive names in this groups are soft focus, diffusion, portrait, fog, mist, halo, low con, net, and spot filters. The means by which these filters work, as well as their actual effects vary greatly. Still, they all share one similar characteristic: They all have some means of redirecting the light. For example, there are tiny silver particles embedded in the glass of a Nikon Soft filter, a black or white netting material stretched across the surface of a net filter, irregularities such as bubbles or ripples placed on the filter surface, or even tiny lenses as found in the Zeiss Softar filters. All of these constructions selectively redirect some of the light, preventing it from focusing correctly. The result can be anything from the mitigation of minor facial flaws to an overall decrease in contrast, or even the formation of halos around highlight areas.

Netting material placed over a lens can mitigate minor facial flaws in portraits. The size of the net pattern determines the strength. The smaller the pattern, the stronger the effect.

top row: Grade 2, 3, and 4 black net filters
bottom row: White net filter, warm net filter

Which Filter to Choose?

The best way to approach this diverse grouping is to establish what effect is desired in the first place. Over the years, I have identified the specific effects that I want to achieve and found the filters that produce the desired results. The list below is by no means complete, and the descriptions are an entirely personal interpretation. Nevertheless, it can serve as a useful starting point for anyone who wants to develop his or her own list.

Category 1: Takes the edge off the image sharpness to reduce minor facial flaws without lowering contrast. Black net filters work best as do the weakest soft focus filters, such as Nikon Soft 1 and Zeiss Softar 1. The Tiffen Soft/FX 1 and 2 produce a slightly stronger effect.

Category 2: Produces noticeable image softness with minimal loss of contrast. This category includes moderate soft focus filters, such as the Nikon Soft 2, Zeiss Softar 2, and Tiffen Soft/FX 3 and 4.

Category 3: Reduces contrast with minimal image softening. This is a specific characteristic of the weaker Tiffen Black Pro-Mist filters. Most diffusion filters in 2 and 3 strength also fit into this category.

Category 4: Gives the look of fog or mist with the possible addition of halos around light sources. This includes any of the stronger filters labeled as "Fog" or "Mist" along with the strongest diffusion filters. Also, combining the Nikon Soft 1 and 2 will mimic this effect. Tiffen's Pro-Mist filters deliver a range of atmospheric effects in strengths from 1–5. Don't be afraid to combine two different types of diffusion filters for a more extreme effect

Adding Warmth

Because soft focus filters are often used for portraiture, many manufacturers have begun offering filters that combine soft focus and warming effects. Most companies add a slight color-cast equivalent to an 81A light balancing filter to their more popular soft focus offerings. If you already have a warming filter and a soft focus filter that you prefer, there is no reason not to try using the two together.

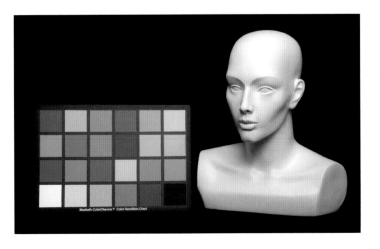
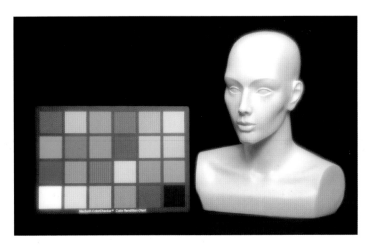

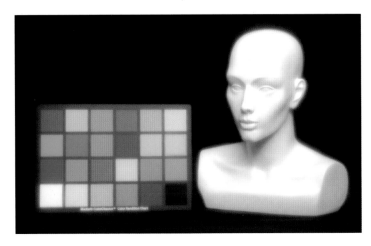
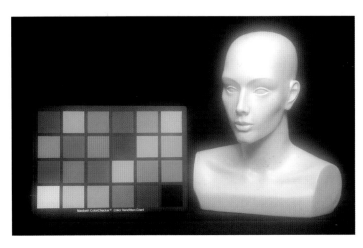

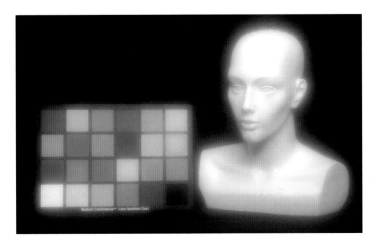
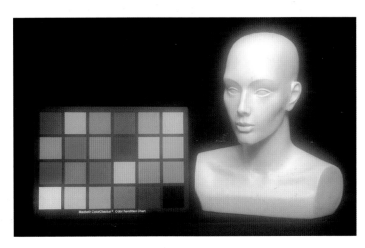

These images illustrate the wide variety soft focus effects that can be produced.

top row: No filter, Zeiss Softar 1 (category 1)
center row: Nikon Soft 2 (category 2), Tiffen Black Pro-Mist (category 3)
bottom row: Tiffen Pro-Mist (category 4), Tiffen Warm Black Pro-Mist

CLOSE-UP FILTERS

Close-up filters work just like a magnifying glass placed in front of the lens allowing it to focus closer and therefore give a magnified view of the subject. The quality of these filters can vary between those that use a single element and ones that are far more expensive because they use multiple elements. Generally speaking, results from the few multi-element designs are very good, whereas the quality of single element close-up filters can vary greatly. The less expensive close-up filters are rated according to their diopter strength. The most commonly available are +1, +2, and +3 diopters with the higher numbers giving greater magnification. The multi-element filters use different designations depending on the manufacturer. For example, Nikon's +1.5 and +3.0 diopter filters have names specific to the size of the lens mount. The 3t (1.5 diopter) and 4t (3.0 diopter) close-up filters fit 52mm lenses while the 5t (1.5 diopter) and 6t (3.0 diopter) fit 62mm lenses.

FILTER MATERIALS

The materials used to manufacture a filter can certainly make a difference in the quality of the final image. In theory, the perfect filter is made from a totally clear matrix material such as glass or plastic resin that will not change the color content of the light or disrupt its path in any way. This allows whatever active filter material is added to the matrix to produce its effect without any contamination or disruption. In practice, however, there are impurities in filters that can introduce unintended or undesirable changes or effects. For example, if the filter's matrix material is not completely neutral, it can produce a color cast independent of (or in addition to) the filter's function.

Whenever light passes through a material, it changes direction due to the process of diffraction. That is, when light passes through a plane, its straight path will be disrupted to some degree. To minimize this effect, the two surfaces or planes of the filter need to be manufactured so that they are absolutely parallel.

The vast majority of filters today are made of either optical glass, rigid optical resin plastic, or various film-like materials commonly referred to as gels. By far, the most popular materials are glass and resin. Photographers will often argue over the merits of glass versus resin, and which material produces the best image quality. The reality is that there is no simple answer. There are several variables that can affect the final image, including the quality of the manufacturing process and levels of quality control for both the filter matrix and the active materials used in the filter. In addition, the actual size and shape of the filter may come into play. The larger the filter area is, the more difficult it is to maintain strict manufacturing controls.

The best way to determine the quality of a filter is to photograph a lens test chart with and without the filter using the same aperture.

Then there is always the question of how the photographer uses the filter. Is the photographer shooting in the studio or out in a swamp or a desert? Glass filters are more scratch resistant than resin, but they also break more easily. Multi-coatings or super multi-coating on filters are said to better control the image degrading effects of flare. Now mix in advertising claims that are issued all too often without independent testing data and the situation really gets confusing.

So how does a photographer wade through the variables to decide which filter to buy? Based on my experience with hundreds of filters from numerous manufacturers used with both film and digital cameras, certain conditions seem to prevail. First of all, high quality images are possible with both glass and resin filters; one material is not absolutely better than the other. Consider, for example, very expensive and highly respected brands like Heliopan and B+W that emphasize the purity of transmission for the glass used in their filter lines. Yet a manufacturer of no less a revered reputation for quality than Sinar has a complete line of resin filters for use with their high-end lenses.

While not a perfect indicator, price tends to be a good predictor of overall quality. That is, the old adage "you get what you pay for" seems to hold true. This does not mean that the more you pay for a filter, the better your images will be. On the contrary, such mid-priced brands as Hoya, Cokin, and Tiffen are quite capable of delivering more than acceptable results for most photographers. On the other hand, it must be acknowledged that some photographers will insist on buying the most expensive brands of all photo equipment, including filters. But the question is, does the extra money buy a noticeable difference in quality?

Generalizations and manufacturers claims aside, the only way an individual photographer can determine if a particular filter is up to his or her standards is to run some simple tests. The best approach is to employ the same procedures used to test lenses. Photograph both a typical subject and a test chart that gives a measure of resolution as well as color, white, and middle gray areas with and without the filter; then compare the resulting images. The lighting, lens focal length, and film choice or digital camera white balance selection should be representative of conditions under which the filter will be used. Look for differences in resolution and color rendition between the "with" and "without" filter images. Take the time to do some testing—it is the only way to tell for sure. Or to put it another way, one test is worth a thousand opinions.

FILTER MOUNTS AND FILTER CARE

Thread-Mount Filters

Filters are mounted on camera lenses using one of two basic configurations: thread or screw mounts, or bracket holders. Thread mounts are the most common. Circular filters are mounted within a threaded metal ring that is sized to fit the threaded front of a camera lens. For lenses that take thread-mount filters, the filter size is expressed in millimeters. Circular filters are available for almost every size lens that is made. Ultra wide-angle lenses and long telephoto lenses have such large front elements that thread mounts aren't practical. These lenses have a "drop-in" filter mount—a slot located near the lens mount that accepts a circular filter.

Generally circular filters have both a male and female threaded end, which allows multiple filters to be used together. In fact, a convenient way to store and carry circular filters is to thread them together in a stack and protect the ends with a set of threaded end caps.

One variation on the thread mount for circular filters is the bayonet mount. These are made for lenses—usually for earlier Hasselblad and Rollei cameras—with a bayonet mount rather than a threaded ring. Bayonet mount filters are now less common and offer only a limited number of choices. Adapters are available to put threaded filters onto bayonet-mount lenses.

Filter Step-up and Step-down Adapters

Most photographers have lenses that require different threaded filter sizes. It is cost effective to standardize and buy filters in the largest size. Lenses with smaller thread sizes can be fitted with a step-up ring that fits the bigger filter. Step-down rings are also available allowing the use of a smaller filter on a larger lens. This practice, however, can cause vignetting, a noticeable darkening of the image corners due to the undersized ring blocking some of the light. Vignetting can also be a problem with wide-angle lenses, especially if two or more filters are stacked. In general, the shorter the lens focal length, the more likely it is that vignetting could occur.

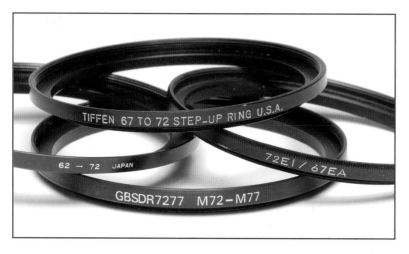

Step ring adapters allow a large filter to be used on a lens with a smaller filter mount. A photographer can buy filters in just one size to fit several lenses.

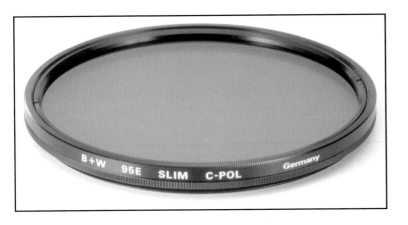

Several manufacturers are making filters with a low profile mounting ring to help avoid vignetting with wide-angle lenses.

Manufacturers have tried to prevent vignetting by making filters with a thinner ring than standard designs. There are also special wide front-end designs that feature a flared front. Both of these filter types help when using one filter on a very wide-angle lens (24–28mm range with 35mm photography). In the case of super wide-angle lenses, it is impractical to use anything but oversized filters, such as larger bracket-type rectangular and square designs.

Bracket Mount Systems

Bracket-style filter mounts can be attached to a wide range of different size lenses using separate threaded rings that can be inserted into the bracket holder. These holders will then take one or more of the same size square or rectangular shaped glass or resin filters. Thus, one filter can be used with different size lenses. This is also the preferred system when using graduated filters since these need to be adjusted by sliding them up and down in the bracket.

Bracket mount systems received a major marketing boost from the Cokin Filter Company. Today, there are other systems available, such as those from Lee Filters. Some manufacturers also make their own filters to fit brackets made by these companies. When selecting a bracket system, consider two factors: the largest lens diameter in your camera bag and the widest lens. In both cases, the potential problem is vignetting. Thus, photographers will often opt to use larger-sized bracket systems when using ultra wide-angle lenses. Examples include the Lee Filter system or the Cokin "P" and "X-Pro" systems.

Unlike resin and glass filters, gels are made of thin film-like material and require a holder to keep them rigid. Bracket mount systems are typically used with gel holders. In addition, some bellows-type lens hood designs have slots for holding gel filters. Gels come in different sizes and they can be easily cut if necessary. In general, they are primarily used for studio photography. Color compensating filters are frequently used to tightly control color reproduction. Gels are the least popular filter type for outdoor photography. This is due primarily to their flimsy nature and the wear and tear of everyday use in the field. On the other hand, some filter designations are only available as gels. Weak color compensating filters and special filters for infrared photography are two examples.

PUTTING TOGETHER A FILTER KIT

Photographers who rely on filters in their everyday work will often have a combination of circular and bracket systems in their camera bags. This is a very flexible approach since it gives the photographer access to the widest possible range of effects and therefore the most appropriate filter or filter combination for the job. I usually carry as many as 25 or 30 different filters in a waist pack when working either with film or "35mm-style" digital cameras. The threaded filters in this kit represent many different brands and measure 72mm. All

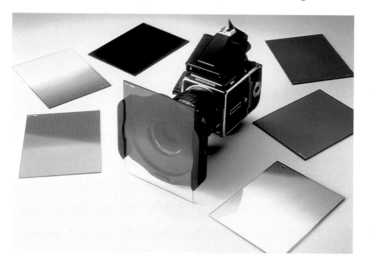

lenses with smaller filter sizes are equipped with step-up rings. The bracket-style filters are rectangles or squares from various manufacturers standardized to fit a Cokin "P" holder. For medium-format lenses and panoramic photography, I use 77mm and 82mm filters with the Lee filter bracket system. I also have some 77mm circular glass thread-mount filters from various manufacturers. These filters are also used with ultra wide-angle 35mm SLR lenses.

Point-and-Zoom Camera Filters

All of the filter designs described in this chapter are for use with a wide variety of camera designs and formats, including SLR (Single Lens Reflex), ZLR (Zoom Lens Reflex), TLR (Twin Lens Reflex), rangefinder, non-rotating panoramic cameras, as well as large format cameras. This is because all of these cameras use lenses with standard sized thread or bayonet mounts. Using filters with so-called "point-and-zoom" digital or film cameras, however, present some challenges because these models have small, odd-sized thread mounts or no filter mount at all.

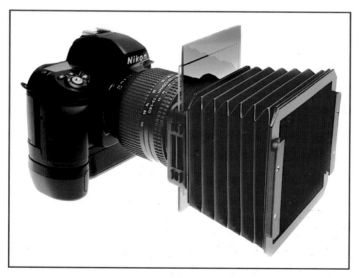

Bracket mount filter systems are based on a universal holder, such as the Cokin "P" holder. These systems typically offer a variety of solid-colored and graduated filter types (top). Additional accessories such as bellows hoods are also available. The Lee bracket holder can be expanded to fit multiple filters (bottom).

As point-and-zoom digital cameras have become more sophisticated, more models are now "filter friendly." Thus, users of point-and-zoom cameras will have to do some research to find out

what, if any, filters are available for their particular model. As an alternative, it is often sufficient to simply hold a filter in front of the lens of a point-and-zoom camera taking care not to scratch it against the lens barrel. This is certainly not an ideal situation but the results may justify the inconvenience of taking pictures in this way.

Filter manufactures such as Cokin, Tiffen, and others do produce adapters for filter use with point and zooms. The new Cokin bracket system that provides for the use of Cokin "A" filters with many, if not most, point-and-zoom cameras, is a particularly creative approach. This bracket arrangement also gives the user access to one of the most extensive filter lines available, as well as filters from other manufacturers that fit the Cokin holder.

Storage and Cleaning

Caring for filters follows the same general procedures as caring for the front element of a lens. That is, blow off any debris before actually cleaning the filter. Standard lens cleaning fluids, lens tissue, and silk lens cleaning cloths can be used with glass filters. Check the manufacturer recommendations for how to clean specific resin filter brands. Gel filters scratch very easily and are hard to clean without damaging the surface—another strike against this design. In the case of circular designs, always protect a filter by storing it in a case or in a filter stack with end caps. Bracket mounted filters should be stored in separate cases or a filter pouch. Small zippered soft cases designed for CD storage can hold most rectangular filters. It is also good practice to place a lens cap over any filter attached to a lens when the camera is not in use.

The temptation to overtighten a filter or filter ring should always be avoided, as it can result in a "frozen filter." If this happens, try gripping the ring with several fingers and the thumb distributed around the ring to prevent the ring from being squeezed and distorted. Alternatively, place the filter face down into the palm of the hand and turn the camera using the whole surface of the palm to apply an even holding pressure on the filter ring. This can also be done using the soft sole of a shoe or sneaker instead of the hand. Filter wrenches, which apply even pressure around a filter to loosen it, are available in camera stores.

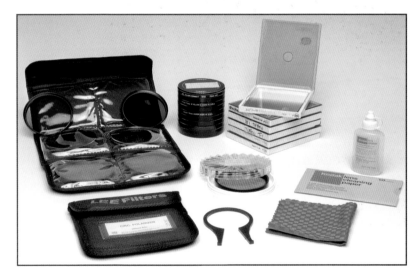

A complete kit for filter care and storage.

Using Filters with Digital Cameras

Consistently, we hear from photographers starting to work with digital cameras who believe they don't need filters anymore. This is absolutely not true!

–Rob Sheppard, Editor, *Outdoor Photographer*

The overall purpose of this chapter is to examine how filters can be used effectively with digital cameras. In addition, the last half of the chapter will cover a list of those filters that I have found to be essential when working with digital capture. Like the editor of *Outdoor Photographer* in the opening quotation, I too am amazed to hear anyone assume that digital photographers cannot benefit greatly from the use of filters. On the other hand, it really needs to be stressed that digital cameras do have different operational characteristics that affect which filters to select and how they are used. Consequently, this chapter begins by looking at these important camera characteristics.

DIGITAL CAMERA CHOICES

Today's photographer can select from a wide variety of digital cameras. Choices begin with relatively inexpensive point-and-shoot models that produce low to moderate quality images all the way up to high-end professional equipment in the $20,000–$30,000 category. In general, filters can be used with all digital cameras but their effectiveness and convenience will vary significantly with the specific camera design and model.

In the most basic operational terms, digital cameras really break down into two broad categories: cameras that allow the user to see the filter effect through the viewfinder and cameras that do not. We are concerned primarily with digital cameras in the $500 to $5,000 category. Consequently, the specific information that follows will concentrate on cameras in this price range. These collectively break down into three distinct groups: "35mm-style" digital SLRs with interchangeable lenses, ZLR (Zoom Lens Reflex) cameras with permanently attached zoom lenses, and point-and-shoot cameras with zoom lenses (sometimes called point-and zoom cameras).

HOW DIGITAL CAMERAS RECORD LIGHT

All digital cameras use electronic sensors to translate the RGB wavelengths of light into electronic signals. These signals are then processed by the camera's software into a file that will appear as a photographic image when opened with appropriate software. The light hitting the sensor is actually captured within millions of tiny pixel receptor sites on the sensor's surface. These pixels are divided up into red, green, or blue sensitive sites.

SLR-type camera

ZLR-type camera

Point-and-shoot camera

Today's photographer has a wide variety of digital cameras from which to choose. The technology keeps improving and becoming more affordable.

This is accomplished, incidentally, by coating each pixel with colored filter materials so that two of the three primary wavelengths are blocked allowing only one to get through to each pixel site. Thus, a digital picture can really be thought of as a mosaic image made up of individual red, green, and blue signals from these tiny pixel receptors.

Noise and Sharpening

The processing software of the camera that assembles an image from the red, green, and blue pixels must deal with the fact that each pixel is only capturing a portion of the color information. The level of sophistication in the mathematical models and data processing used to produce an image in-camera will greatly determine the quality of the final image. In addition, there are a number of ways the image signal can gain unwanted additional electronic signals. These extra signals are collectively referred to as "noise." A typical example of noise is the speckled appearance of what should be a smooth, evenly colored surface. For the most part, noise is considered undesirable since it really is extraneous information that appears with the image signal. Conversely, some noise in a digital image can break up the overly smooth, electronically perfect nature of the digital image.

MOSAIC CAPTURE

The surface of the digital camera's sensor is divided into red, green, and blue sensitive sites. Each pixel site is coated with colored filter material so that two of the three primary wavelengths are blocked.

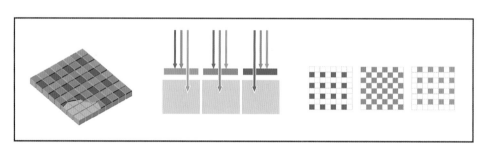

Color filters are applied to a single layer of photo-detectors in a tiled mosaic pattern.

The filters let only one wavelength of light pass through to a given pixel.

Mosaic sensors capture only 25% of the red and blue light and just 50% of the green.

X3 CAPTURE

Foveon's recording chip, the X3 Sensor, records all three primary wavelengths of light at one pixel site. The chip can fit three times as much data into the same recording space.

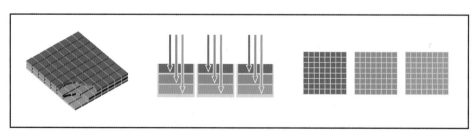

An X3 image sensor features three layers of photodetectors embedded in silicon.

Silicon absorbs different colors of light at different depths, so each layer captures a different color.

An X3 image sensor can capture red, blue, and green light at every pixel location.

ILLUSTRATIONS COURTESY OF FOVEON, INC.

Enlarged sections from a digital photo of a white lily show color and surface artifacts. It is possible to significantly reduce these unwanted signals using noise reduction techniques.

Quantum Mechanic Pro from Camera Bits diminished the color artifacts to some degree.

The Photoshop Gaussian Blur filter smoothed out surface irregularities more successfully.

It is possible to detect which color channel has the most noise by examining each one individually from Photoshop's Channel palette. The original full color image was captured as a JPEG file at ISO 1600 with a digital SLR. The top right photo is the red channel, the bottom left is the green channel, and the bottom right shows the noisiest channel, the blue channel.

Beside the appearance of noise, the captured image will also appear soft partly because the pixels are only picking up part of the color information. This can be countered by having the camera's software sharpen the image or by using sharpening software (e.g. an unsharp mask filter) in the computer. While having the sharpening done in camera may seem to save time, the best results are usually accomplished in the computer for several reasons. The computer offers various sharpening options and the ability to undo any results. If sharpening is done in camera with the TIFF or JPEG formats, it becomes a permanent part of the image. The skilled digital photographer knows that different light, different subjects, and even different areas of an image will often require different levels of sharpening. This can only be done in the computer.

Recently, the Foveon Corporation introduced a recording chip called the "X3 Sensor" in which all three RGB primary wavelengths of light are recorded at one pixel site. Because the Foveon sensor captures all the light data at each pixel site, the manufacturer claims that the final image contains less noise while packing three times more data into the same recording space. Hence, the "X3" reference in the name. It will be interesting to see how well the X3 chip effects the quality level of digital imaging when it becomes widely available in cameras. According to Foveon, there is no substantial difference in the effects of filters captured with their sensors as compared to conventional sensors.

Can Camera Filters Remove Digital Noise?

The best answer is that they can mask some of the noise. For example, using a strong soft focus, diffusion, or fog filter will usually blur the detail structure of noise so that it is less evident. If, however, the noise is strongly colored, using these filters may not be especially effective. A much better approach to dealing with noise is to work with a noise-filtering program in the computer. The different ways to reduce noise in the computer are covered in the last three chapters of the book.

KEY DIGITAL CAMERA FUNCTIONS AND FILTER USE

There are a number of digital camera functions that affect how filtration can be used with a particular camera. These are:
• White balance features
• Quality of the LCD playback
• The influences of different ISO, contrast, and color saturation settings
• Type of viewfinder
• Lens filter mount
• Sensitivity to wavelengths outside the visible spectrum
• Availability of a RAW file capture option
• The ability to close focus

White Balance Features
One of the most important capabilities that digital cameras have in relation to filter use is the White Balance (WB) feature. This dial-in function adjusts the way colors will appear in the recorded image. White balance can be thought of as an adjustable color temperature setting. The photographer selects from such preset white balance categories as Daylight, Flash, Tungsten, Cloudy, Shade, and Fluorescent. These white balance settings are the electronic equivalents of using color conversion and light balancing filters with film cameras.

These sports photos demonstrate the use of a digital camera's white balance settings to correctly record colors under various lighting conditions. While not perfect in terms of color correctness, these settings generally provide more than adequate results, which can then be tweaked later in the computer.

The images were captured using a digital SLR. White balance was set for the lighting indicated.

A: Lacrosse field, hazy sunshine, ISO 400
B: Soccer field, late afternoon sun ISO 200
C: Squash court, fluorescent, ISO 800
D: Hockey rink, mixed halogen lighting, ISO 1600*
E: Football field, overcast/light rain, ISO 1600
F: Basketball court, tungsten, ISO 800
G: Baseball field, bright sunshine, ISO 400

*Because of the mixed lighting in the hockey rink, a custom WB was set using a gray card.

A

B

C

For example, in the series of sports photos shown on these two pages, the colors and neutral areas all appear reasonably correct because the appropriate white balance setting was used for each of the seven different types of lighting.

In addition to preset white balance settings, most digital cameras will also provide for an automatic white balance or "Auto WB." As the name implies, automatic white balance adjusts the recording of colors automatically for the lighting conditions present. I have found that the accuracy of automatic white balance will vary among camera models as well as with the type of light. In general, the more expensive SLR cameras produce better overall results. Unusual light sources such as Sodium Vapor lamps present a real challenge to all cameras.

D

E

F

G

Some of the more sophisticated digital cameras also have a custom white balance feature. This function allows the photographer to set the white balance to a specific light source. This is done by pointing the camera toward a completely neutral white surface or a white card and activating the custom function. With some cameras, an 18% gray card—the type used for exposure metering—will work as well.

Custom white balance is particularly helpful when the lighting in a scene is mixed because it allows the photographer to set the white balance for a specific light source. For example, envision a situation with a person illuminated by daylight from a window with tungsten light in the background of a room. The automatic white balance might seem a good choice. Actually, it is not. The best choice is a custom white balance set for the window light since it is the main light on the subject. With Auto WB, the camera will try to balance the color temperature of the light between the background tungsten light and daylight.

Consequently, custom is generally the most accurate form of white balance for two reasons. First, the preset white balance settings of digital cameras are based on an average color temperature for these conditions. The lighting may actually be different by several hundred degrees. Second, (as in the window light example just mentioned), the lighting may be mixed and the photographer should set the white balance for the main subject light.

Setting White Balance with Color Filters

Once a preset or custom white balance setting (but not Auto WB) is dialed into the camera for correct color balance, the photographer can then modify the capture with color filters according to his or her preferences. For example, an 81A or 81B light balancing filter might be used to warm up the light of an overcast day or an 82A blue filter could be used to either neutralize the warmth of late afternoon sun or give mid-day light a slightly cooler look. The choice here is a personal one, but the need to select the proper white balance setting is critical to produce the desired effects with colored filters.

At this point the reader may be asking, "Why bother using conversion and light balancing filters if the digital camera can correct for various types of light?" Good question—the answer can be found within the goals of the individual photographer. If the purpose is to correctly record colors and neutral areas, then careful use of a digital camera's white balance function as described above will do the trick in most situations. But it is safe to say that most photographers have a preference for a certain look, and want to interpret a scene or a subject in a unique way. Consequently, the use of filters to enhance the rendering of the light, colors, or tonality suits their own purposes.

Also, there is the question of workflow. How do you want to spend your time; photographing different interpretations of a subject or changing the captured image in the computer? Each reader has to answer this question individually. I feel the best time spent in photography has always been with the camera and subject creating different versions of the image and taking advantage of changes within the scene. I use the computer to refine and extend what the camera captured.

Avoid Auto White Balance

It is extremely important to understand that if the Auto WB setting is used, a digital camera will adjust for the effect of the filter color. In other words, the Auto WB will negate most if not all of the desired effect. For example, an 85B amber conversion filter might be used to create the look of a sunset in a landscape photo. If the camera is on Auto WB, it will actually compensate for the filter's warmth. By using the camera's daylight white balance setting, the filter effect will be evident. The basic rule of thumb with color filters is to avoid Auto WB. Instead, use the preset white balance that matches the light source. If you cannot match the source, use the Custom WB before adding the filter.

Using White Balance Creatively

Beside their corrective roles, a digital camera's white balance settings can be thought of as a set of ready-made, built-in colored filters that can be dialed in for creative effects. This happens when these settings are purposely mismatched with certain types of lighting and/or combined with one or more filters. The series of photos on this page used various preset white balance settings under the same mid-day lighting. Notice that the significant color shifts are very similar to the kinds of color changes one would expect when using the following filters:

Preset White Balance	Filter Equivalent
Cloudy	81A or 81B
Shade	81C or 81EF
Fluorescent	CC20-30M
Tungsten	80A

B

C

D

A

White balance settings can simulate colored filter effects. These photos illustrate the color shifts that occur when various white balance settings are used in sunlight.

A: Daylight white balance setting
B: Cloudy white balance setting
C: Shade white balance setting
D: Fluorescent white balance setting
E: Tungsten white balance setting

E

LCD Viewing Screen Quality

In theory, the LCD screen on a digital camera functions like an "electronic Polaroid." It provides a preview of what the camera will capture. In practice, it is quite difficult to judge correct exposure from a 2x2-inch image on a screen. On the other hand, the more expensive digital cameras do offer data readouts in the form of histograms that are a far better indicator of proper exposure.

When it comes to judging color and the effects of various colored filters, especially the weaker varieties, the typical LCD screen again leaves something to be desired. At best, colors in the image can be considered only a fair representation of what has been captured.

One useful LCD feature is the ability to zoom in and examine the image up close. This is a great help not only for checking general levels of sharpness, but also for examining the results from soft focus and diffusion filters. You can usually get in close enough to see the effect on small details that will disclose how the filter is altering sharpness.

Another problem is the difficulty of viewing images on the LCD in bright sunlight. Aftermarket hoods do help by shielding the LCD screen.

Hoods that shade the camera's LCD screen make it easier to view images in bright sunlight.

ISO, Contrast, and Color Saturation Settings

Another unique quality of digital cameras is the option to change the light sensitivity of the sensor. Light sensitivity is expressed in digital cameras as with film cameras by using ISO (International Standards Organization) ratings. Thus, the higher the number, the greater the sensitivity to light and therefore the less light needed to produce a correctly exposed image. In addition, some cameras will also provide different settings for contrast and color saturation. These are meant to adjust to different contrast levels of light as well as appeal to personal preferences in the saturation level of colors.

While most photographers will select a film speed based on the amount of light present, many will also select a speed for its look. The slowest ISO setting —typically ISO 100—will generally give the best overall quality and least amount of noise while higher speeds tend to have more noise. In addition, higher speeds will not record shadow and highlight values as well as lower speeds.

The ability to use digital cameras at high sensitivity ratings in conjunction with computer controls can produce unique effects. In this photo of struggling football linemen captured with a digital SLR and a 400mm lens on a gloomy overcast day, an ISO 1600 setting combined with an excessive amount of Photoshop's Unsharp Mask filter emphasized the grainy look.

The "gritty" look of a high ISO appeals to some photographers just like high-speed films. On the other hand, other photographers will follow the rule that the best images are those captured at the lowest ISO settings and avoid using the faster ISO ratings whenever possible. Thus, what is not acceptable to one photographer can be desirable to another.

Types of Viewfinders

Cameras in the point-and-zoom digital category use a viewing system separate from the lens. The effect of a filter placed over the lens is not seen in the viewfinder. Almost all of the digital SLRs and ZLRs using a "35mm-style" camera body have an optical viewfinder that allows the photographer to see the scene through the lens. In general, the optical SLR viewfinder is the most accurate arrangement for viewing the effect of a filter. This is especially important when using graduated, soft focus, polarizing, and various special effect filters, such as starbursts.

There are digital SLR cameras that have electronic viewfinders much like those of a video camera. While these will also show a filter effect, the electronic viewfinder uses a video signal, which does not have the realistic qualities of the optical image. This will require the photographer to spend a little time adapting to how various filters are displayed.

Lens Filter Mount

Unlike digital SLR and ZLR cameras, the lenses on many point-and-zoom cameras, particularly the less expensive models, do not have filter mounts. That is, most lenses are not threaded to accept screw mount filters. Other models have very small or unusual size thread mounts, and there are a limited number of filter types made for these camera models. But for many photographers, the easiest way to use a filter with a point-and-zoom camera is to handhold a filter in front of the lens. This is not a convenient approach, but it is effective.

One practical solution for using filters with point-and-zoom cameras is a holder manufactured by Cokin. It allows the extensive Cokin "A" filter line to be used with most non-SLR cameras.

Most point-and-zoom digital cameras have a close-up mode that can produce remarkably good images, as seen in this photo taken with a 2.1 megapixel camera and lit with the built-in flash.

Sensitivity to Infrared Light

Some digital cameras are capable of recording infrared light when filtration is used to block visible light. Filters that do not block all the visible light produce images that are a mixture of infrared and high-contrast panchromatic effects when the digital camera is set for monochrome capture. If the camera's sensor is very sensitive to infrared light, denser filters such as the Wratten 87 and 87C filters can be used. The mnochromatic images that result closely resemble photographs produced with KODAK High Speed Infrared Film. This subject will be covered in greater detail in the chapter on black-and-white photography.

RAW File Capture Option

Some digital cameras offer a RAW file capture option as well as TIFF and JPEG formats. This file format records the raw light without processing the digital data, unlike TIFF and JPEG files. Consequently, this type of recording allows the photographer to use computer software to change several key qualities such as the white balance and exposure. This important feature is covered in detail in Chapter 4.

The Ability to Close Focus

The ability of digital SLR cameras with interchangeable lenses to close focus will depend on the lens that is used. There is always the option to use a close-up filter with any lens on these cameras to get closer to the subject. In the case of ZLR cameras, each model will differ somewhat, but in general, these cameras can focus a short distance from the subject with the addition of close-up filters.

In the case of point-and-zoom digital cameras, close up functions can range from good to remarkable. The usual procedure is to place the camera in close-up mode and allow the autofocus to lock on to the subject. Frankly, I have been very impressed by the ability of even moderately priced point-and-zoom cameras to capture close-up images.

THE MOST USEFUL DIGITAL CAMERA FILTERS (AND WHY I USE THEM)

Here is my list of filters that I have found to be most effective with digital cameras. Some are used individually and some are combined with other camera filters. Or, in some cases, the filter effect is augmented by the camera's white balance setting. Also, this list is admittedly a biased collection but one that, hopefully, will allow the reader to see some of the many possibilities for creating different images with filters.

One question that is frequently asked during seminars on using filters is whether or not it is okay to use more than one filter simultaneously. It is true that some photographers refuse to use any filters because they feel it will degrade image quality. Other photographers will only use one filter and avoid multiple filter combinations at all costs. As far as I am concerned, these are self-imposed rules made up to satisfy an individual's conception of how the tools of photography should be used. From a creative point of view, I feel that they are really self-imposed limitations.

Filters are tools that are capable of producing many, many different effects. Just like the arguments over the quality of single focal-length lenses versus zoom lenses, or fast films versus slow films, it all comes down to how an individual photographer uses these tools. But just imagine how many great photographs would never have been made if creative photographers had listened to what they should not use in their work? Thus, from this photographer's point of view, multiple filter use is an extremely valuable option.

Polarizing Filters

As explained in the last chapter, the polarizer can darken clear skies, remove or reduce reflections, and act as a neutral density filter in a pinch. This one-sentence description of its functions does not really begin to explain the many ways this filter can change an image. For example, by removing glare, the polarizing filter will appear to impart a higher level of color saturation. This can be seen in a number of different lighting situations, such as when photographing fall foliage after a rainstorm, or in a distant landscape on a sunny day. In both cases, the colors will appear more deeply saturated because the polarizer reduces the reflections coming off the shiny leaves while darkening a blue sky. Also, when shooting with black-and-white film, a polarizing filter will darken the sky without affecting the tonal representation of other colors in the scene.

I frequently use a polarizer in combination with other filters. For example, in landscape photography, the polarizer darkens blue skies. I often add a graduated ND filter to give the blue sky more gradation. A color effect can be added using any of the light-balancing filters or a weak color compensating filter. Adding a soft focus or diffusion filter then gives an atmospheric effect to the warm or cool mood.

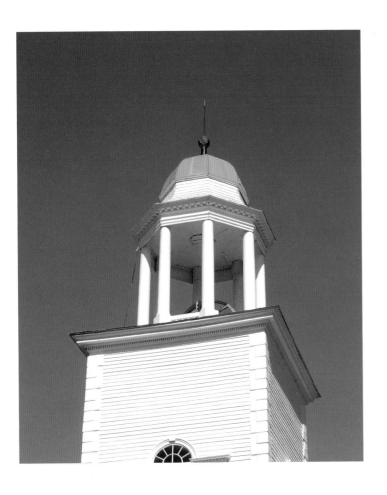

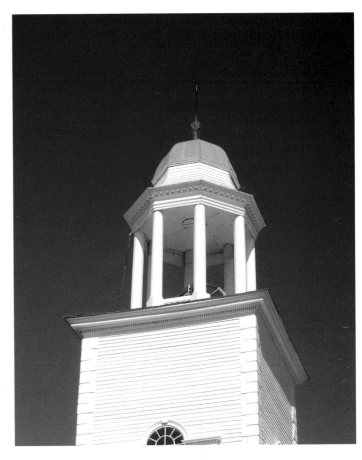

top left: No filter

top right: Maximum polarizing effect on a clear blue sky.

bottom left: Maximum polarizing effect with a warm polarizer

These photos clearly demonstrate the darkened sky that is produced when a polarizing filter is used. It almost overwhelms the details of the steeple. Fortunately, the effects of a polarizer can be varied by adjusting the filter rotation. All photos were taken with a digital SLR and a 24–85mm zoom lens.

Cross polarization refers to the technique in which polarizing filters are placed on both the light source and the camera to remove virtually all glare from shiny surfaces. Typically, this is used with a copystand setup. In the photo on the left, there is only a polarizer on the camera. The photo on the right shows the effects of adding polarizing sheet filters over the copy lights. Notice how the cross polarization not only removes the remaining reflections on the photos, but also the general surface reflections to produce a more saturated rendering.

Recently, I have been combining a polarizer with my digital camera's preset white balance function to mimic the look of a warm polarizer. By selecting the Cloudy or Shade setting in daylight, images pick up a slightly warm color cast.

For copy photography, polarizing filters placed over the light sources can be used in combination with a polarizer on the camera. This cross polarization is a very effective way to remove glare on items being photographed.

Two Cautionary Notes on Polarizers:

1. There are actually two types of polarizing filters—circular and linear. A circular filter will work well with all types of automatic and manual focusing and metering systems and is recommended for use with cameras having modern autofocus and TTL (through the lens) metering systems. A linear polarizer will interfere with the function of these systems.

2. Plexiglas and other similar clear plastic materials will likely show a rainbow-like pattern in photographs when a polarizer is used. This is produced because these materials do not transmit all wavelengths of light uniformly.

Graduated Filters

After the polarizing filter, the graduated neutral density filter is, in my opinion, the most useful filter for digital and film capture. The reason is its ability to lower contrast in overly bright areas so that the camera can record data in every area of the scene. Without the graduated ND filter, certain areas, particularly sky areas, would be "blown out" and no detail would be recorded. Most graduated color filters will also lower the contrast between the sky and foreground while adding a color effect.

While the most popular uses of both color and ND grads are to affect the sky area, there are certainly other applications. These filters can help with a foreground that is either too bright or can benefit from the addition of some color. Incidentally, my digital SLR filter kit includes Tobacco 1, Blue 1, Grape 1, and Magenta 1 graduated color filters as well as 0.3, 0.6, and 0.9 graduated ND filters. All these are used with a Cokin "P" type bracket holder with a 72mm adapter ring. All the lenses with filter mounts smaller than 72mm have step up rings. Here is a checklist of techniques to consider when using graduated filters:

• Graduated ND filters work equally well for both color and black-and-white photography.

• You do not have to use the full neutral density field. A graduated filter's effect can be varied by raising or lowering the filter in its bracket holder. In some situations, only a small portion of the filter is needed.

• The density of a graduated color filter can be increased by first setting the color filter in position and then adding a graduated ND filter.

To produce unique effects, graduated filters can be used in combination with other filters. This photo used a Cokin graduated magenta filter in the sky plus an 80A filter to give the water more of a blue appearance.

• Lighter graduated color filters will add color to a sky or foreground area with minimal effect on exposure. Thus, you may find that metering through the filter produces an accurate exposure. An 0.3 graduated ND filter can then be added to increase density if needed.

• If you cannot find a ready-made duotone graduated filter to your liking, try placing one graduated color filter over the upper portion of the picture and a second grad filter in the lower area.

• Finally, here is an important point from the Singh-Ray filter website regarding the use of a graduated filter on a digital camera (www.singh-ray.com/digital.html): "When working with graduated ND filters, you will be using only the central 2/3 of the total filter area. The graduated density area—starting from the clear lower half of the filter up to the area of fullest neutral density—will span a relatively larger area of your final image than it would if you were using a 35mm film camera. This difference tends to convert the gradation of the hard step filter to a much softer gradation."

Neutral Density Filters

At first glance, selecting a neutral density filter as one of the most useful filters may not sound like a logical choice since photographers are usually more concerned with having enough light. But neutral density filters are almost a necessity for capturing the unique and fascinating imagery that is possible when using slow shutter speeds to record moving objects. Actually, most digital cameras are geared up for medium to high ISO capture. Consequently, slowing the shutter speed to anything less than 1/30 second and still maintaining a correct exposure with smaller apertures becomes a problem.

It is quite surprising how often a neutral density filter comes in handy, allowing you to shoot at a desired aperture and shutter speed combination. Even at the digital camera's lowest ISO of 200 and the smallest aperture of f/16, a one-stop neutral density filter was needed to slow the shutter speed down to 1/15 second. This added a little blur to the photo to enhance the feeling of movement.

Neutral density filters are available to alter exposure by one, two, or three stops and will easily allow for shutter speeds of 1/8 or 1/4 second in bright light. Such speeds permit the photographer to capture subjects in motion using a technique called panning. For example, if the photographer keeps the camera trained on a runner, with a shutter speed of around 1/8 second, this person will maintain a degree of sharpness while the background blurs into streaks. For best results, a small aperture should be used and the subject should be moving parallel to the film plane.

I always keep two ND filters in my bag (1 and 3-stop versions), not only for panning, but also to use in low light settings. Occasionally, I will combine both ND filters for a total light loss of four stops. I can use extremely long shutter speeds measured in seconds (sometimes minutes) on an overcast day or in the shade of the forest to produce, for example, the angel hair effect with moving water.

A two-stop neutral density filter allowed for a moderately slow shutter speed. The author then panned the camera with the moving bicyclist to blur the background and imply motion.

Soft Focus and Diffusion Filters

Selection of a particular soft focus filter effect is a very individual decision that depends not only on the subject but also on the style and preferences of the photographer. My filter kit for typical portrait situations contains the following: the Nikon Soft 1 and 2, the Zeiss Softar I and II, and the Tiffen SoftFX 2 and 3. (The weaker filters are used for male subjects and stronger ones for females.) For atmosphere and mood, I prefer the Tiffen Hollywood FX Pro-Mist filters or a combination of the Nikon Soft 1 and 2.

There is the time-honored trick of applying a very thin coating of oil from one's nose to an UV or Skylight filter to produce a slight but noticeable overall soft effect. This technique will also pick up streaks from light coming in through a window. The only time I bother with UV or Skylight filters is when I am altering them in this way.

In this portrait of three youngsters, a Zeiss Softar I filter took the edge off the sharpness. Because the photo was taken in shade, a Tiffen 812 warming filter was added to clean up the blue color cast and brighten the brick background.

Keeping a variety of soft focus and diffusion filters in your bag means being prepared to photograph any subject and take advantage of different types of lighting. This extremely moody shot of a jazz musician gives the impression of a poorly lit, smoke-filled jazz club. It was taken with a strong Warm Pro-Mist filter from Tiffen.

For years I have relied on various types of net filters to conceal minor facial flaws in portraits. Unfortunately, using these filters on digital cameras often results in a net pattern. Only a few of the weaker net filters seem to avoid producing this artifact. Definitely test this type of filter at different aperture settings on your digital camera.

One of the few disappointments with digital cameras is that many net filters produce the kinds of artifacts seen here. Black net filters seem particularly prone to producing this effect.

In this shot of a professional model, a Nikon Soft 2 created a pronounced soft effect with a slight glow to the highlights.

Close-Up Filters

Today's multi-element close-up filters made by camera manufacturers such as Canon and Nikon produce excellent results when used on high quality lenses. I use the Nikon 5T and 6T multi-element filters, often combining the weaker 5T with the stronger 6T for shooting extreme close-ups. The only real drawback is that this combination will not have the complete focusing range of a true macro lens from very close to infinity.

I have generally found the single element close-up filters to be inadequate in terms of image quality, especially at the edges. Of course, the best approach to close-up work always begins by using a good quality macro lens. If you're very interested in shooting close-ups with a digital camera, consider buying a camera that accepts interchangeable lenses.

This photo of a snapping turtle hatchling was taken in direct sunlight with the close-up mode of a 3.1 megapixel point-and-zoom digital camera.

Using close-up filters to decrease the minimum focus distance of a lens is an option with all digital SLR camera models. Multi-element filters typically give the best results. Both the tulip (above) and the leaf (below) were taken with a 1.5 diopter multi-element filter and lit with a studio soft box.

Sepia and Enhancing Filters

There are several filters that I favor for warming up a scene. These include the enhancing and sepia filters and the 85B. I stopped carrying 81-series warming filters and now emulate their effects in the computer with RAW format files as covered in Chapter 5. I still carry Tiffen Sepia #1 and Singh-Ray Enhancing filters. They deliver strong results and each has a unique coloration that I have not really been able to duplicate in the computer.

The Sepia filter is usually associated with an "old-fashioned" look and it will certainly give that result. But I have found that the weakest version will give a strong warm-up in bright mid-day sunlight and I especially like the effect that this filter creates for portraits lit with indirect north window light coming from a blue sky. Try this filter with the Shade and Cloudy preset white balance settings to produce an even stronger warming effect.

The 85-series color conversion filters are strong warming filters and I only reach for them when the scene *really* needs to be rendered with warmth. To the eye it may seem that sunsets do not require such treatment, but when recorded on film, the warm, vibrant light often appears almost neutral or lacking in color. Clouds, mist, or other atmospheric conditions can be the cause. When photographing a sunset, my 85B filter comes out of my bag along with a 0.6 or 0.9 graduated neutral density filter to hold back some of the sky's brightness.

In summer scenes, the 85A filter plus a weak diffusion filter create the impression of the three H's—hot, hazy, and humid. I have found that this filter combination is especially effective if a scene includes water or with subjects backlit by a low late afternoon sun.

The red enhancing filter is theoretically a warming filter, but the way it pumps up red values limits its use to a few subjects that benefit from this color boost. It is really a filter for the landscape shooter, especially for capturing fall colors. The green and blue enhancing filters have similar uses for their effects on foliage and skies respectively. At a recent workshop, I was shown examples of a warm enhancing filter used for a scene of the southwest United States just as the sun was setting. The reddish enhancement of the rocks and sand was most impressive. A red enhancing filter does not work well for portraiture because it tends to bring out too much red in skin tones.

A warm tone is associated with old black-and-white photographs, which were commonly treated with sepia toner. The look is reminiscent of yesteryear, as seen in these "before-and-after" comparison photos of school memorabilia. A #3 sepia filter was combined with a soft focus filter. Also, the image corners were darkened using the Burn 4 Corners filter in the Pixel Genius PhotoKit software. This enhanced the "old-fashioned" effect, as light fall-off was characteristic of many older lenses.

Cooling Filters

It is not typical for a photographer to want to cool the colors in a scene, but when this is required, the 82-series filters can be quite useful. Usually, this happens when there is a need to correctly record colors and the light source is a bit too warm. For example, the color of a fashion model's clothes may need to be recorded correctly while photographing in late afternoon light. There are also times when a blue color cast works as a compositional element. For example, images of metallic, technical, or industrial subjects, such as a tall glass and steel office building, can often benefit from the use of either one of the 82-Series filters. Switching the camera's preset white balance to the Incandescent or Tungsten setting for a daylight shot will give a similar effect.

As with the 81-series however, I have found that it is not worth carrying 82-series filters unless I am shooting film. Instead, I use a RAW file capture and then tweak the results in the computer. I do use the blue 80A color conversion filter for many sunset seascapes because it shifts the dark reddish water towards blue. On a dreary gray day, try shooting with the digital camera's white balance set on Tungsten and an 80A filter to change the overall gray appearance to a definite "blue mood."

As mentioned in Chapter 1, twilight has a time when blues and reds mix, resulting in a short-lived magenta period. This lighting can be enhanced by using a weak 10 or 20 CC magenta filter. As an alternative, try placing the camera's white balance on its Fluorescent setting for a similar effect. One of my favorite filter combinations for twilight just after the sun has gone down is a weak graduated Tobacco filter for the sky paired with a magenta filter (or the Fluorescent white balance setting).

Twilight is a magical time for photography. Even with no filtration, the light produces a combination of soft and strong colors and ordinary objects are rendered in a unique way.

The obvious use for the magenta camera filters and the Fluorescent white balance setting is, of course, to mitigate or eliminate the green in fluorescent lighting. As detailed in Chapter 2, several filter manufacturers offer special fluorescent filters for use with either daylight- or tungsten-balanced films. A very similar effect can be produced by using a magenta color compensating filter. A CC20M filter is usually the best choice to eliminate the green color cast of fluorescent light. By the same token, special fluorescent filters as well as the magenta CC filters can also be used to warm up the twilight period when light is beginning to go blue-gray.

This significantly warmer photo was taken with a Cokin 85B and the Cokin filter holder described in Chapter 2.

4 Filter Software for Color Correction

Color is the most malleable and creative quality that light has to offer the photographer willing to try something new.

Over the past few years, many specialized filter programs have come on the market as either standalone products or plug-ins for imaging software, such as Adobe Photoshop, Adobe Photoshop Elements, Corel Draw, and Jasc Paint Shop Pro. Many of these filter programs are intended for the graphic design market and emphasize typography and image manipulations favored by illustrators and graphic artists. An increasing number are clearly directed at photographers interested in quick and easy color correction methods and emulating on-camera filter effects. Besides replicating traditional filter effects, some of these electronic filtration programs go beyond what any existing filter can produce.

There are at least 50 current filter programs on the market. Those directed at photographers vary from large multi-filter packages to small programs that concentrate on just a handful of effects. A sampling of filter programs demonstrates that some programs come boxed as a CD complete with printed manuals while others can only be purchased as downloads from websites. Many are also available in trial versions, allowing potential buyers the opportunity to try before they buy. The majority of software is available in both Mac and Windows versions. Most of the illustrations for this book were produced on a Macintosh computer. Windows users can assume that their version has the same main functions and basically the same operational look and feel.

Besides the specialized photo-filter programs featured in the next three chapters, special attention is given to demonstrating filter techniques using Adobe Photoshop, the most popular general imaging program in use today. While it takes a considerable effort to become an expert in Photoshop, this program does come with a number of built-in filters that even non-experts can easily use to refine an image; in particular, those in the "Artistic" filter groupings. The examples of these filters used in this book can be found in all versions of Photoshop, from 5.0 upwards, along with some additional simple-to-apply Photoshop functions.

Finally, there is a way of taking advantage of some of the advanced filtering power of Photoshop without having to become an expert. Packaged Photoshop Actions are available to carry out a series of image alterations automatically. With this approach, the user simply clicks the mouse and converts a color photo to black-and-white with any of the contrast filter options, or applies a specific warming or cooling filter. These packaged Actions are for sale

Filter software programs can come as CD packages complete with printed manuals or as downloads from websites. In many cases, potential buyers can download a trial version of a program that expires after a period of time or after the program is opened a certain number of times.

on websites from various sources, such as Fred Miranda and Pixel Genius. The spreading popularity and relatively low cost of this approach undoubtedly means that more packaged Actions offerings will be showing up in the internet marketplace.

The approach throughout the next three chapters will be to demonstrate the various ways a photographer can apply filter effects in the computer using these methods:

• Specialized image manipulation software
• "One-click" Photoshop filters and functions
• Packaged Photoshop Actions

Both the corrective and creative aspects of filter software are explored. The common characteristic for all programs is the relatively easy way in which various effects can be applied. The presentation of each operation is in the form of a set of examples with "before" and "after" images.

This chapter deals with software techniques for color correction. Specifically, it covers four different approaches to rendering color correctly. Chapter 5 considers other color operations, such as emulating warming and cooling filters and restoring faded color in photographs, as well as adding special effects. The chapter ends with a look at noise reduction programs. Chapter 6 covers camera filters and software for black-and-white photography, as well as filter programs for producing "the look of film," perspective correction, and various optical effects.

The top dialog box shows a Photoshop Levels histogram while the bottom image is the Photoshop Curves dialog box. Other imaging programs have comparable functionality. These are two of the most useful controls for image manipulation and it is important to be familiar with the operation of these critical controls.

FILTER PROGRAMS

With so many programs and filter effects to consider, it is not possible to show every filter variation for each of the programs selected. The fact that a particular program is used to show a specific effect does not mean that it is the only program that can accomplish the effect. Rather, the purpose of the next three chapters is to give you a general idea of how software can be used for both corrective and creative purposes. Be sure to check out each company's website for a more complete picture of the software.

The typical specialized filter program opens on your computer screen with a dialog box containing controls and a small preview image. These controls commonly take the form of sliders that change one or more qualities of the image. Adjustments are reflected immediately in the preview image so you can judge the results. These changes can then be applied to the original image usually with the click of the mouse. Unfortunately, there are no standards as to the way various controls are designed, so each program is really somewhat unique in this regard.

The effectiveness of a program begins with the tools provided within the dialog box and ends with the quality of the changes in the original image. Here is a rundown on certain characteristics and functions that I have found to be important when working with these programs.

How Much Control Does the User Have?

Usually, the better programs provide the user with a range of controls for making changes. For example, separate sliders for brightness and contrast offer more options than just a single control for exposure. The notable exception to this is the typical packaged Actions software. With these Actions, the user usually has only pre-determined choices to manipulate the application of an effect. For example, a warm filter effect offers a choice of four different intensities: Warming #1, #2, #3, or #4.

A useful dialogue box for a filter software program is one that offers individual adjustments for each function. Notice that the adjustable sliding scales also have numerical readouts. This is very helpful for recording exact settings, making it easier to recreate effects.

Are Results Easily Duplicated?

The settings for each control should be clearly represented; numeric values work well. It should be easy to determine and duplicate the settings for the purposes of replication. One of the shortcomings of certain programs (and of some Photoshop filters) is that the controls are difficult to reset for easy replication. This makes it very hard to reproduce an effect in a series of images. As a matter of course, I copy down settings or take a screenshot of the dialog box for my records.

How Accurate is the Preview Image?

One annoying problem with some programs is that the surrogate preview image does not accurately represent the final appearance of the full-size image. This can be a real detriment, especially when trying to achieve very subtle changes.

Does the Software Add Noise?

It is not uncommon to notice additional noise as a result of digital image manipulation. This is a difficult side effect to quantify, but in general, applying several extreme changes with any software is an invitation to increase the noise level. Noise levels can often be mitigated with specialized noise reduction software as explained in Chapter 5.

Is the Program a Memory Hog?

A few of the very powerful programs, like Applied Science Fiction's ROC, require quite a bit of RAM and will quit during processing if they cannot access that RAM. Be sure to check the software's memory requirements and allocate enough RAM. Powerful programs may also tend to run slowly, so be patient.

The accuracy of the preview image is another important factor to consider. Changes seen in the preview should reflect how the actual image will look. Also, it is helpful if the software offers the ability to change the magnification of the preview image.

A Word About Adobe Photoshop

Adobe Photoshop is the most widely used of all general imaging programs among photographers. It is the standard for professional photographers and most serious non-professionals. There is even a national organization, NAPP (National Association of Photoshop Professionals) that publishes the magazine *Photoshop User* and maintains an active website (www.photoshopuser.com). NAPP also sponsors Photoshop World, an annual convention that features the latest digital imaging technology as well as instructional seminars. Recently, NAPP has begun offering workshops throughout the U.S.A.

As a further indication of Photoshop's dominance, the vast majority of specialized filter programs are designed to operate as Photoshop plug-ins. The image is opened in Photoshop and then the plug-in is accessed through Photoshop; it usually appears in the Filters menu.

Photoshop has grown into a very powerful and complex imaging program. It takes a significant commitment of time and effort to become proficient. Many photographers are not able to spend countless hours in front of the computer while delving through 400+ page books or attending intensive workshops. Just a glance at the number of books published on Photoshop each year will attest to not only the diversity of this program but also its steep learning curve for becoming a real expert.

For this reason many software companies have found a market for specialized imaging programs that use a less complex interface and easy-to-understand commands. It is also why Photoshop Actions packages will probably grow in popularity and why this book was written.

Photoshop User magazine is published by the NAPP (National Association of Photoshop Professionals).

CORRECTIVE VERSUS CREATIVE APPLICATIONS

All of the software programs covered in this book were created to perform specific tasks; for example, to remove a color cast or add a diffusion effect. As with camera filters, I view the original purpose of a tool as a beginning point rather than as an end point. Just as with camera filters, the general approach in the remaining chapters will be to demonstrate the intended purpose of a program and then explore its creative applications.

Using a program for a purpose other than for what it was intended can sometimes reveal a new technique. For example, the JPEG Repair function of Alien Skin Image Doctor applies a smooth appearance that can also be used to eliminate or at least reduce a distracting texture in a picture.

To Tweak or to Transform?

The filter programs featured in this book are capable of radically changing an image in seconds. With each change the photographer should ask a basic question, "Do I like this new form of my picture?" The ease of making changes in the computer creates results that have the potential to radically alter one's frame of reference.

I am certainly not proposing that the reader change his or her personal photographic style because of the opportunities offered by software. Rather, this is just a cautionary note.

As hinted at in the chapter's opening quotation—the ability to produce something beyond what was originally conceived when the picture was taken can act as a harbinger of a change in one's values.

The original image (above) was altered using filter software programs featured in this book. The five enhanced images (right) were all produced with just one or two clicks of the mouse.

Strategies for Color Correction

There are a number of different approaches to rendering color correctly in a digital image. As explained in the first chapter, matching the camera's white balance with the temperature of the light source at the time of capture is the most common way to insure correct color rendering. With film, this means using the proper color conversion or light balancing filter to adjust the colors in the light to the film's rating. In this chapter, attention is turned to producing correct color using computer software following one of four different strategies.

1. The first software option can be characterized as a "second chance" to refine the white balance setting of a digital camera. This is done through the use of RAW file capture. Unfortunately, not all digital cameras have the ability to record images in this format. As a general rule, the more expensive point-and-shoot models, as well as all digital SLR models, have this option. As demonstrated below in the example section, manipulation of the RAW file is a very effective way to insure a proper color balance between light and camera.

 Camera manufacturers offer proprietary software to open and adjust the RAW format files from their cameras. Adobe offers a plug-in that is a RAW file reader. It allows a photographer to open RAW files from many different brands of digital cameras.

2. The second software approach is to use a program that is designed to perform general color corrections. That is, if your camera does not have a RAW format option then you are most likely dealing with a TIFF or JPEG file capture. Also, flatbed and film scanners typically save files as TIFF files. Several programs in this book have functions that automatically carry out general color corrections.

3. There is also an approach to color correction built on the proper rendering of neutral tones. People are most sensitive to color shifts in neutral areas. An observer is most likely to notice a color cast in a white or neutral gray area. Thus, the strategy is to balance the neutral area and give the impression of correct color. Removing a color cast from a neutral area is not a perfect solution, but it is an improvement and may be all that is needed.

4. A more limited form of color correction occurs when there is a need to adjust only one single important color. A common example is the rendering of skin tones in a portrait. Only a small amount of adjustment may be needed, but the results can be critical if this color is key to the rendering of the subject. Even untrained observers are likely to notice incorrect color in a subject for which there is a standard of sorts, for example, the red in a stop sign or the green of evergreen trees. Fixing such colors will invariably improve the image in terms of how it is perceived as a correct representation of reality.

Color Correction Examples

So let's have a closer look at these four approaches to color correction by examining specific examples.

Example 1: Color Temperature Correction with RAW Files
(Software: Nikon Capture, Adobe Photoshop RAW Plug-in)

The RAW file format gives photographers the ability to change the specific color temperature of the captured image in the computer. This change is essentially a chance to go back and adjust the white balance prior to taking the picture.

The photo of the rose was captured in the RAW file format used by Nikon called NEF format (Nikon Electronic File). It was opened within Nikon's proprietary Capture software. I photographed this for a Nikon advertisement for the Nikon D100 digital SLR. Adobe has recently released a RAW file plug-in for Photoshop. The Nikon Capture software will only read files in Nikon's NEF format, while the Photoshop plug-in reads files from most major camera manufacturers. (Check the Adobe website for a complete list of camera models.)

RAW file processing software allows you to change the color temperature by just a few degrees or as much as several thousand degrees. This covers the range of what light balancing and color conversion filters can do. Color correction is accomplished by moving a slider. A numeric readout displays the changes in color temperature. These changes are reflected in the preview image. In addition, there are provisions for making adjustments to the exposure.

Nikon Capture software reads Nikon's proprietary NEF RAW files.

The Adobe Photoshop RAW file plug-in can read RAW files from a variety of cameras.

The four photos above show the change that is possible with a single color subject. Using Nikon Capture software, the white balance of the RAW file was adjusted.

top left: Flash 5,600K
top right: Shade 8,000K
bottom left: Cool White Fluorescent 4,100K
bottom right: High Color Fluorescent 3,000K

on the opposite page:
The images on the near right show a Macbeth Color Checker photographed under 3,200K lighting with the camera set for Daylight white balance. This produced an orange color cast.

The images on the far right show the results of resetting the white balance to the appropriate 3,200K using the Adobe Photoshop RAW plug-in. The colors and grays on the chart appear correct.

Once adjustments are made, the file can remain in the RAW format or be saved as a TIFF or JPEG file, as well as other file formats. Converting files to TIFF or JPEG means that they can be opened and manipulated with software programs that are not able to read RAW files. If you save the RAW file intact, you can go back at any point and change the color balance and exposure as many times as you wish without permanently affecting the file or losing data.

Saving as a TIFF file can also be "lossless;" there is an option to save with no significant loss of data with this file format. You do give up the ability to change the color temperature and exposure settings with the specificity of a RAW file. Instead, you have to begin with whatever level of color data and exposure was saved to the TIFF file from the original RAW file. You can then use other software programs to alter the color further. The same is true of JPEG files, except that some image information is lost due to compression.

Shooting in a RAW format and using appropriate RAW processing software provides a photographer with tight control over image processing. If measurements of the light sources are taken with a color meter, corrections in the color balance of the RAW file can be very precise. Adjustments can be made "by the numbers" instead of subjectively adjusting the image on the computer screen. In general, the skillful use of the RAW format really eliminates the need for color conversion and light balancing camera filters.

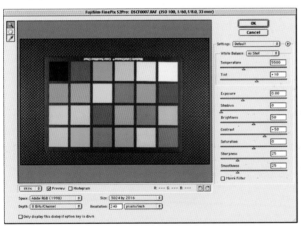

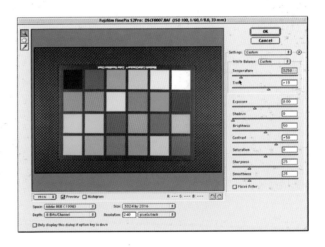

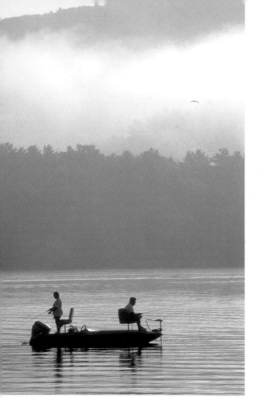

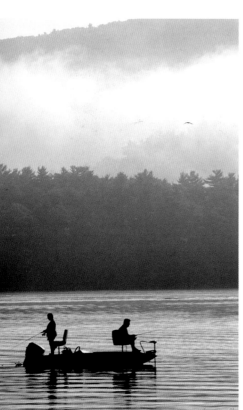

The blue color cast of the original digital capture (top) was removed using Digital ROC and Digital SHO.

Example 2: Using Software for Color Corrections

(Software: Applied Science Fiction ROC and SHO, Color Mechanic Pro, Andromeda RedEyePro, nik Sharpener Pro! Inkjet Edition)

Applied Science Fiction (ASF) established themselves in the software world with the release of their Digital ICE, ROC, and GEM products (known collectively as Digital ICE Cubed). The ICE portion removes dust and scratches, GEM reduces excessive grain, and the ROC portion restores and corrects color. All were initially available only as bundled software with certain film and flatbed scanners. AFS then released a Photoshop plug-in version of Digital ROC and Digital GEM along with a new program called Digital SHO that is designed to improve shadow and highlight areas. I have found ROC and SHO to be very effective at general color correction.

To apply color correction to an image, ASF recommends using both ROC and SHO, beginning with ROC. The photo of the fishermen, originally used on page 19 as an example of the high color temperature of a misty overcast day, was given the ROC and SHO treatment using the software's recommended corrections. That is, the settings automatically calculated by the software were applied. There are controls to make adjustments

manually as well in the Digital ROC and Digital SHO dialog boxes. The automatic corrections are calculated and then the settings are recalibrated at zero. The sliders can be adjusted further to either positive or negative values. Putting a slider back to zero resets the software's recommendation.

In a more complex example of color correction, the Siamese cat was photographed under very weak mixed fluorescent and indirect window lighting at ISO 1600. A 50mm lens at $f/1.4$ was used on a 6 megapixel digital SLR to get this noisy, poorly color-balanced image. The first step was to use Digital ROC software to correct for the green color cast. To fix the exposure, I used Digital SHO and adjusted the automatic correction by an additional +6 Shadow Brightness and -2 Color Intensity. Because I planned to output the file as an 11 x 14-inch inkjet print, I applied the noise reduction application in Quantum Mechanic Pro software.

The original photo (left) and the results of Digital ROC and Digital SHO corrections.

Before the application of Quantum Mechanic Pro noise reduction (left) and after.

The final image, which included enhancing the cat's blue eyes.

The image was looking much better, but I felt that the subject's eyes were not as brilliant blue as they looked in the kennel. Andromeda RedEyePro software gives you the option of easily changing eye color in addition to removing redeye without affecting the catch lights. (This program is demonstrated in Chapter 5, Example 4.) I adjusted the color of cat's eyes until they appeared as blue as I remembered them.

Finally, I applied nik Sharpener Pro!. This nik Multimedia program is designed specifically for sharpening an image for output by ink jet, laser, and thermal dye transfer printers. To avoid any changes in the smooth background area, only the head of the cat was selected for sharpening.

I purposely included the additional image manipulations in this second example of color correction software to illustrate a point. Very often with a difficult image you will find yourself with more than one problem to solve. It may be necessary to use several programs to achieve the results you want in the final image. Also, even though these examples emphasize the use of "one click" programs, it is assumed that there will often be a need to tweak levels, contrast, and sharpness after an effect has been applied. Consequently, these routine procedures performed with Photoshop will not be noted in each example.

The original image (top) and after color correction was applied.

Example 3: Neutralizing a Weak Color Cast

(Software: Color Mechanic Pro, Pictographics iCorrect Professional, Pixel Genius PhotoKit Warming Filter)

The group shot of the Barbershop singers was taken in early winter. This makes it a good example to illustrate how removing a color cast from neutral areas is not always the single answer to color correction.

The blue in the building's walls and columns was neutralized using Color Mechanic Pro. After opening the program, a window appears with two versions of the image and two hexagonal color correction areas. On the left is the input image and on the right is the corrected image. Clicking an area on the input image produces a point on the hexagon. Dragging this point to the white center of the hexagon will neutralize the color. The results can be seen in the image on the right.

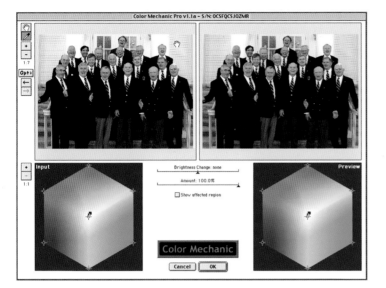

left: The dialog box for Color Mechanic Pro.

below: The dialog box for Pictographics iCorrect and the image after iCorrect was applied.

To neutralize the cool color cast, the selector was placed on the background wall in the area with the highest levels of blue tint. This is a key point when using Color Mechanic Pro. The stronger the shade of the color cast in the selected area, the more complete the removal. Moving the point on the Preview hexagon close to the center removed most of the blue color cast.

Now the cool light of an on-camera flash used as fill light for the faces needed to be warmed up. I have had very good results rendering skin tones with Pictographics iCorrect Professional. (The functions of this program are explained in the next example.) In addition to the iCorrect adjustment, the Photoshop Unsharp Mask Filter (Filter> Sharpen> Unsharp Mask) was applied at 150 percent, 1.2 Radius, 0 Threshold.

I was curious to see if the cool color cast could be corrected by just adding a warm filter software effect. Unlike with camera filters, filtering with software gives you the option of working an image through a series of adjustments. Individual corrections can be made for specific areas of a photograph. Another approach would have been to use an 81A or 81B camera filter in the original shot. This would have warmed the faces. Then, if the image still had a slight color cast, it could be neutralized with the computer.

It is this sort of flexible thinking about combining camera and computer filtration techniques that the knowledgeable photographer should carry into every situation. Trying various combinations is also a way to build experience using both camera and computer filtration. There are few rules to inhibit the photographer who is willing to take chances and try

Using the strongest warming filter from Pixel Genius PhotoKit improved skin tones, but left a cool color cast in the background.

new effects—just be sure to document your techniques so they can be recreated!

Starting with the original unaltered file, I applied the strongest warming filter ("Warming #4") available in the Color Balance Set of Pixel Genius PhotoKit software. While there was a pleasant warming of the faces, the rear walls still showed traces of blue skylight. So in this case, the better approach was to first neutralize the color cast and then deal with adjusting the skin tones rather than trying to do everything with one filter. (Warming filter effects are covered further in Chapter 5, Example 1.)

Example 4: Neutralizing a Strong Color Cast
(Software: Color Mechanic Pro)

Color Mechanic Pro is one of the quickest and most effective programs for removing a color cast from neutral areas with a minimum build up of noise. The "before" example was taken with a digital SLR at ISO 1600 using a 24-85mm *f*/2.8 zoom lens wide open at 24mm. The white balance was set for Tungsten. The image was captured using the highest quality JPEG setting. There is plenty of noise in this image due in part to the poor quality of the lighting and a high ISO rating. The extremely low color temperature of the mood lighting for this event has produced a strong orange color cast in the image, even with the Tungsten white balance setting. This is a good image to test Color Mechanic Pro's ability to remove a strong color cast and to see how it affects the already high noise level.

In the Color Mechanic Pro dialog box, I selected the tablecloth in the lower left extreme foreground and dragged the color selection on the hexagon to line up exactly with the white point in the center. The left hand preview image shows uncorrected photo and the right hand preview image shows what the effect will look like.

Enlarging a section of both the "before" and "after" images makes it easier to check the noise level. As you can see, the noise remains at about the same level in the treated image. This is not always the case, but in general I have found that this software keeps increases in noise to a minimum when correcting for a color cast.

Sometimes the optimum place to put the pointer in an image is obvious. In the dinner photo, the textured non-reflective, evenly illuminated surface of the tablecloth is a good choice. The key is to find a spot that is not overexposed and yet not in the shadows. The point here is you have to give some thought as to where to place the pointer to get the best correction. Fortunately, with digital manipulation you can try again and again until you achieve the desired results.

It is also possible to slightly alter the tone of a color or change it completely by using the same procedure in Color Mechanic Pro. Instead of dragging the color selection on the hexagon to the white point, place it on a different color.

A digital photo taken in low light with Tungsten white balance at ISO 1600.

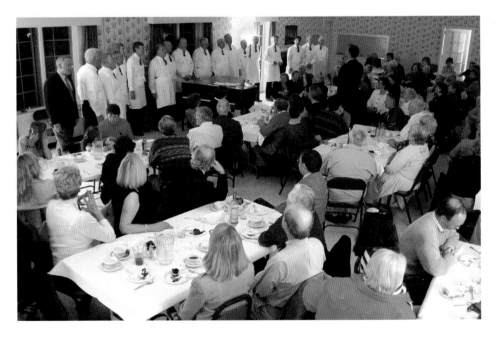

Color corrections made made with the Color Mechanic Pro software (above) are seen in the final image (left).

Enlarged sections of the "before" and "after" images from page 103 show no increase in noise in spite of the extreme color manipulation.

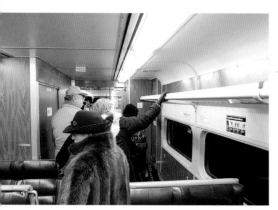

Color Mechanic Pro software is effective at eliminating the "green spike" of fluorescent lighting.

Color Mechanic Pro is particularly effective at removing the green cast caused by fluorescent lighting. The photo (left) taken in a train car is lit with fluorescent lighting. The color was improved using the same one-click white point correction just described. This program also produces good results when a light source with a discontinuous color spectrum is present. Sodium Vapor lighting, for example, displays an extreme predominance of yellow and orange typical of this source.

In general, colors that are significantly different from the selected color will not change. Similar colors, however, will be altered. To keep similar colors from being affected, you can "peg" these similar colors in place. On the Input image, click on the areas of color that you don't want to change. Then, as the last step, click on the color you want to change and drag only its selection point on the hexagon to the desired color. This is not a foolproof way of holding colors in place, but it can work fairly well. Also, take care when making an extreme color change, as when going from red to blue. This sort of alteration is likely to introduce additional noise.

Example 5: Rendering Skin Tones

(Software: "iCorrect Professional)

Because of the difficulty of correctly rendering the subtleties of skin tones, films and photographic papers for portraiture have long been evaluated by how well they reproduce this key element. There is also a significant amount of interpretation that occurs among professionals in portrait work when it comes to rendering skin tones, to say nothing of the preferences of the paying customer. Consequently, the reproduction of a subject's skin tone presents both a challenge and an opportunity for a range of interpretation.

Pictographics iCorrect Professional software has provided a very useful and quick approach for me especially when rendering skin tones in portrait work. The original capture was made using a 3.1 megapixel point-and-shoot digital camera with a single strobe with a soft box positioned straight at the subject just above the camera. The red color cast in the face and arms was intentionally produced by a dark red fabric background, which was arranged so that the light picked up some of its color. The iCorrect Professional dialog box has a selection of Memory Colors, which can be used or modified as necessary. In addition to Skin, other default colors such as Neutrals and Foliage are included. Different color translation values can also be developed and stored.

The dialog box for Pictographics iCorrect Professional software.

As the mouse is clicked on different areas of the subject with different lighting and shadows, the software changes the skin tone subtly. For more extreme changes, other areas of the subject can be targeted. In the lower right photo on page 107, the model's blond hair was selected.

The rendering of skin tones can be somewhat subjective. People's preferences will often vary. Many photo manipulation programs can deliver both a technically "correct" skin tone and also subtle variations. This makes it easy to produce a composite print or "ring around" that shows a subject with several slightly different skin tones.

In that same vein, a program like Vivid Details Test Strip allows the photographer to print out a series of color variations. This is another way of dealing with the complex question of skin tone rendering as well as color correction in general. Once printed, the user then selects the image with the best exposure and color balance and the corrections are applied for the final print.

An example of one of the templates from Vivid Details Test Strip software.

right: The original photo has a slight red cast in the model's face and arms.

on the opposite page:
Four different interpretations of skin tones were produced using iCorrect Professional software.

Enhancing and Refining the Color Image

The ability to produce significant changes with the click of a mouse, to go beyond what was originally seen when the picture was taken, can certainly challenge one's concept of the photographic image.

In addition to the very important process of color correction covered in the last chapter, there are a host of other adjustments and changes that can be made to a color image. For example, warming or cooling effects can be added and colors can be enhanced. All of these alterations were first discussed as functions of light balancing, enhancing, and color conversion camera filters. Other possible effects include adding an overall tone, such as sepia, or adding color to a specific area, such as the sky. All of these effects can be replicated in the computer with the appropriate software. In addition, programs can also produce special effects such as solarization and posterization, to name just two examples.

This chapter also covers the non-chromatic soft focus and diffusion camera filter techniques. This is followed by an analysis of noise filtering programs. As in the last chapter, these techniques will be covered through individual examples.

WARMING AND COOLING THE SUBJECT

There are many situations in which the photographer wants to warm or cool a subject's appearance rather than capture a correct color rendering. This of course, is the role of the 81-series and 82-series light balancing camera filters respectively. For more dramatic impressions, color conversion filters can also be used to establish a mood or enhance a condition such as warming up a weak sunset or producing a real "blue mood" atmosphere on a gloomy, overcast day. All of these effects can be replicated in the computer.

Example 1: Warming Filters
(Software: Adobe Photoshop, Fred Miranda FM Warm-Cool Filter Actions Set)

One of the most common filter applications in portrait photography is to warm a subject with an 81-series light balancing filter. Also, nature photographers are fond of using the 81-series to enhance the light in a landscape or to warm a close-up composition. Photoshop's Color Balance function can approximate the effects of light balancing and color conversion filters. The user needs to know the color composition of the various warming filters and adjust the sliders in the Color Balance dialog box accordingly. Other imaging programs with similar color balance controls can also produce the changes carried out here.

Photoshop's Color Balance dialog box showing the numeric settings that approximate the look of an 81C filter.

The Photoshop Color Balance function is located under Image > Adjust > Color Balance. The specific color values for light balancing and color conversion filters can be found in in the chart below. Keep in mind that there is a degree of variation in the color content of different brands of light balancing filters. After comparing 81-series filters from two different manufacturers, I found noticeable differences in yellow values. Thus, the settings provided should be considered as approximations. You may want to modify them to your own preferences.

In order to get the full effect of each particular filter grade, you will usually need to apply the color settings three times. Use the same values for Highlights, Midtones, and Shadows as indicated under Tone Balance in the dialog box. Individual manipulation of each tone level has the advantage of allowing the photographer to make refinements to each of the filter effects. By not applying the color changes to all three tonal areas, or using slightly different color settings, you can create your own customized warming or cooling filters.

Color Balance Settings that Simulate Color Conversion Filters*

85-Series Color Conversion Filters		80-Series Color Conversion Filters	
85A	-55 Yellow and -20 Magenta	80A	-90 Cyan and -30 Magenta
85B	-65 Yellow and -22 Magenta	80B	-80 Cyan and -25 Magenta
85C	-35 Yellow and -10 Magenta	80C	-55 Cyan and -17 Magenta

Color Balance Settings that Simulate Light Balancing Filters*

81-Series Warming Filters		82-Series Cooling Filters	
81	-5 Yellow	82	-10 Cyan and -5 Magenta
81A	-5 Yellow and -2 Magenta	82A	-15 Cyan and -5 Magenta
81B	-10 Yellow and -2 Magenta	82B	-20 Cyan and -7 Magenta
81C	-15 Yellow and -5 Magenta	82C	-25 Cyan and -7 Magenta
81D	-25 Yellow and -7 Magenta		

*Photoshop Color Balance settings for subtractive colors—cyan, magenta, and yellow—are expressed as negative numbers in the dialog box.

The disadvantage of applying light balancing filter equivalents with Photoshop is that the whole process of adjusting the sliders for three tonal levels can be very tedious. It is also time consuming when you have many images to process. If you are familiar with some of Photoshop's more advanced features, an Action for this procedure can be set, or you can purchase a set of Actions that apply these settings in one click. As an example, Fred Miranda FM Digital Warm-Cool Actions consists of 18 different action sets: 9 warming filters, 9 cooling filters. These cover just about every possible strength variation including Very Warm and Very Cold special effects. A filter effect is applied automatically with the click of a mouse and can be undone just as easily.

This model's portfolio shot—originally used to show the effects of a Nikon Soft 2 filter—is the basis for a series of photos illustrating warming filter effects that can be applied in Photoshop.

Original image

81B equivalent

81C equivalent

81D equivalent

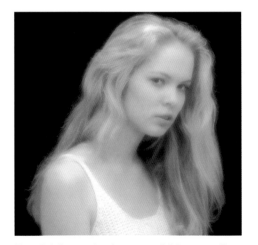

Fred Miranda Actions Warm #5

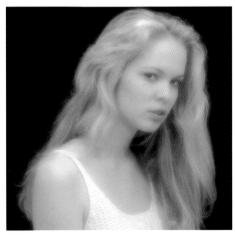

Fred Miranda Actions Warm #6

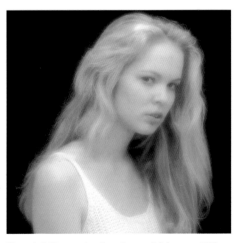

Fred Miranda Actions Warm #7

Example 2: Cooling Filters
(Software: Adobe Photoshop, Pixel Genius PhotoKit)

Using the digital equivalent of an 82-series filter to add a cool color cast is less common than warming up a subject or a scene. The same techniques are used, but with different colors. These filters can be dialed in using the Color Balance feature of Photoshop and the color values listed in the chart on page 110. One technique that can benefit from the equivalent effects of weak 82-series filters is the restoration of aging yellowed photos. The 1930's

vintage wedding photo (opposite left) shows an excessive amount of yellow in what was probably a sepia-toned original. By applying the equivalent of an 82B light balancing filter in Photoshop, some of the yellow was removed while still preserving the "old photo" look.

Another application of the blue light balancing filters is to give an icy cold effect to winter subjects. The picture of frost that formed on a garage window one winter morning was taken with a 3.1 megapixel digital point-and-shoot camera. I first neutralized the green color cast using Color Mechanic Pro. Then, the Cooling 4 filter was applied from the Pixel Genius PhotoKit Color Balance Set, a Photoshop plug-in. Three applications were required to get the desired shade of blue. When working with any software, don't hesitate to apply a particular effect more than once to get the result you want.

To make this photo of frost seem icy cold, the Pixel Genius PhotoKit Cooling 4 setting was applied three times.

Just like an 82-series camera filter, software can be useful for removing excessive warmth in late afternoon shots. In the photo of baseball champions with the coach's young daughter; (top right) a combination of late afternoon sun and reflections from the red uniforms has produced an excessively warm color cast. I applied all of the four cooling choices from the PhotoKit Color Balance Set to show the range of change available with this filter program. Applying a digital filter is different from adjusting the color balance since we are not trying to zero out a white area. Rather, the use of these filters is affecting the overall coloration and mood of the scene.

The color correction applied to this 1930s wedding photo approximated the effect of an 82B filter.

The original digital capture (top) was a little warm. The color was adjusted with Pixel Genius PhotoKit Cooling 2, 3, and 4 filters.

Example 3: Color Conversion Filter Effects

(Software: Adobe Photoshop)

The strong coloration produced by color conversion filters can be reproduced digitally. The pure effects of these Photoshop filter equivalents can be seen in the scene of a snowstorm in the western town of Bryce Canyon, Utah.

The original scene was captured on slide film while testing a new 645 SLR for a magazine article back in the early 1990's. Color conversion filter equivalents are applied with Photoshop in the same way as light balancing filter equivalents, using the appropriate Color Balance settings.

Photoshop Color Balance can also be used to mimic the effects of color compensating filters. Simply dial in the single color of the CC filter effect you want. In the photo below, the original blue color cast of the scene was changed to strong magenta by dialing in -20 magenta for each of the three Tone Balance levels.

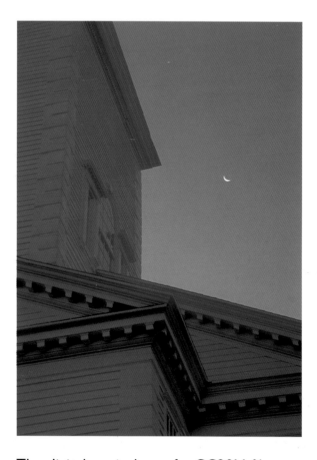

The digital equivalent of a CC20M filter.

The original photo (top), digital versions of an 80A filter (center) and an 85B filter (bottom).

ADDING, INTENSIFYING, AND RESTORING COLOR

In the first chapter, the point was made that an observer's sense of contrast in a scene can be influenced in a number of ways. One approach is to add color to major areas that have little color content, for example, using graduated color filters on a bland clear sky. In addition, there are times when using an enhancing filter to intensify certain colors improves the color contrast. An increase in saturation of all colors caused by a polarizing filter can also increase the sense of color contrast in a scene. In old color photos that have not been stored properly, often the color base has faded and the image contrast needs to be restored. All of these processes can be carried out effectively in the computer.

Example 4: Graduated Color Filter Effects
(Software: nik Color Efex Pro)

The nik Color Efex Pro software package has an extensive selection of graduated colored filters that are very easy to apply. In addition, there is an option called User Defined that allows the user to create graduated filters of any color. Consequently, this extensive filter program can deliver a complete range of graduated effects including a gray version, which acts like a graduated Neutral Density filter.

The available range of preset nik graduated filter effects can be seen in the drop down menu list. The dialog box that comes up when one of these graduated effects is selected has controls for the hue and size of the graduated area as well as where the effect will actually occur. In this example, four different filters were applied to the sky portion of an image to produce four different looks.

The nik Multimedia Color Efex Pro software is a Photoshop plug-in accessed through the Filter menu. It has an extensive selection of graduated effects as well as a custom User Defined option.

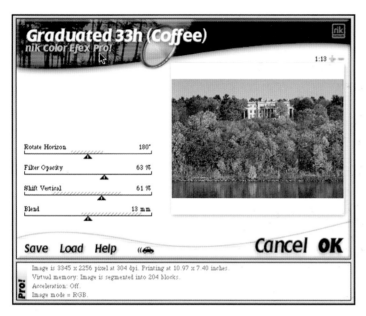

The dialog box for the nik graduated filters has an ample image preview and gives the user a great deal of control over the filter effect.

above: The original image
right: Graduated Coffee filter

On the opposite page
top: Graduated Yellow filter
center: Graduated User
Defined Blue filter
bottom: Graduated Gray filter

The photo of the Vanderbilt Mansion on the edge of the Hudson River in Hyde Park, New York is a section of a panoramic shot. The equipment used was a custom built 6 x 17-cm panoramic camera with a Singh-Ray Red Color Intensifier filter. While the shot shows good autumn colors, the sky is quite bland. Consequently, this image could certainly benefit from the addition of color with a graduated filter effect.

I frequently add digital graduated filter effects to skies and occasionally foregrounds as well. While I always prefer to apply a graduated filter when shooting an image, there are plenty of times when it is appropriate to do it later in the computer. I often use the computer to intensify a graduated camera filter effect as well. The nik Color Efex Pro graduated filter effects are useful for enhancing images with weak sky areas.

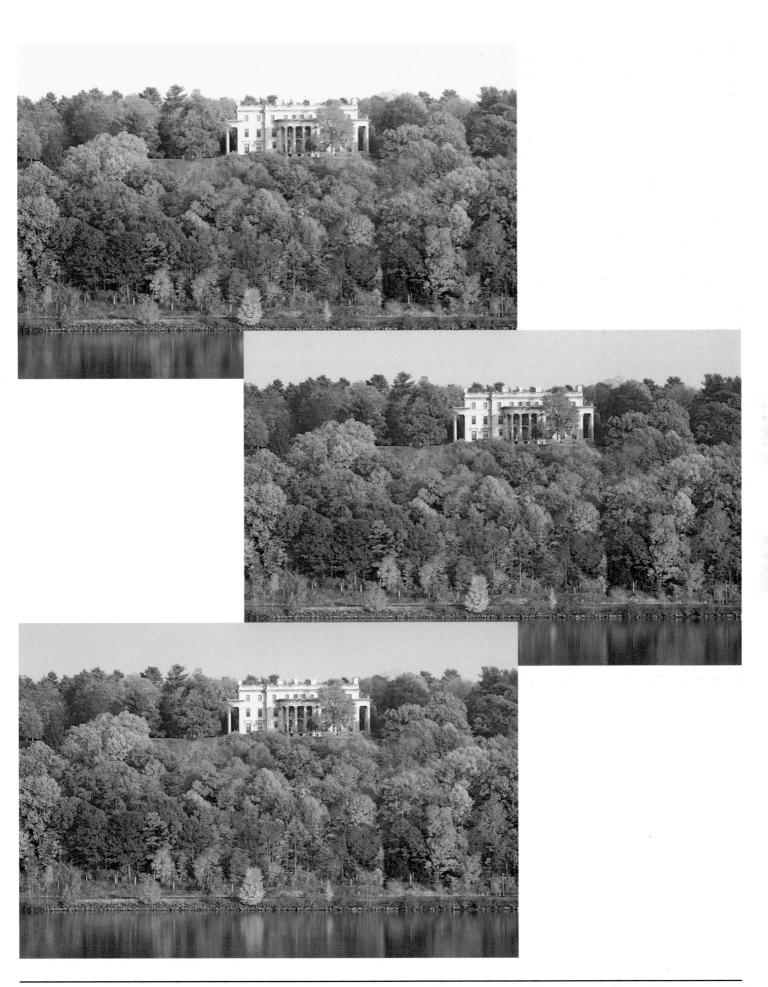

This aerial photo was taken with a 3.1 megapixel digital point-and-zoom camera. Using Digital ROC and Digital SHO improved the contrast and enhanced the colors.

Example 5: Intensifying Colors
(Software: Applied Science Fiction Digital ROC and Digital SHO, nik Color Efex Pro)

Various filters are used to boost the colors in a scene. For example, enhancing filters increase saturation of specific colors, and polarizers reduce glare and increase overall color saturation. Selecting a software program that will produce similar effects will depend on the image and what needs to be done to the image.

In the aerial photo above, taken with a 3.1 megapixel point-and-zoom digital camera, the colors are dull due to glare and also because the scene was shot through a Plexiglas window.

I was able to improve the overall appearance of the photo by using Applied Science Fiction Digital ROC and Digital SHO. While I would not label these two programs as "enhancing filter software," they can pull up muted colors rather well. You can then use the controls in the ROC dialog box to enhance the appearance of a certain color or colors.

A digital polarizer cannot duplicate the ability of an on-camera polarizing filter to remove or reduce reflections. The nik Color Efex Pro Polarizer does a decent job of darkening clear blue skies and adding color saturation to distant landscapes. It appears to do this by enhancing color and increasing contrast.

To demonstrate the blue sky effect of the nik Polarizer, I selected a shot of New York City's famous Flatiron building taken with a digital camera. The nik Polarization dialog box has two settings: Rotation and Strength. By manipulating these two controls, I was able to significantly increase the density of the blue sky.

The nik Polarizer will also bring up color in landscape shots much like a conventional polarizing filter, but it can also produce some unwanted effects. The critical factor to avoid is the build-up of contrast in areas that do not need it. In the photo of the shaded soccer field, the foreground already has plenty of contrast, but the distant mountains show the typical muting effects of haze and UV light. To avoid adding additional contrast in the foreground, the lasso tool in Photoshop was used to select the background from the tree line just beyond the field to the mountains and sky. The nik Polarizer was then applied at full strength.

The original image (top) shows the effects of haze and UV light. The bottom photo had the nik Polarizer applied to only the sky and distant mountains.

The results of the nik Polarizer can be seen in the photo on the right.

Example 6: Restoring a Faded Color Photo
(Software: Applied Science Fiction Digital ROC and Digital SHO)

The scrapbook craze of recent years has increased interest in restoring and printing copies of old photographs to place in albums. Trying to restore the exact colors produced by a particular film and paper that is 30-50 years old is, needless to say, difficult. Thus, restoration really comes down to what you think the colors should look like.

The test photo is a 40+ year-old original color print that was scanned into the computer. As the other colors faded over time, yellow became the dominant hue. Applied Science Fiction (ASF) Digital ROC and Digital SHO Photoshop plug-ins were then used to restore the colors and contrast so they appeared as they did in the original photograph. ASF is said to be able to restore faded colors to their original intensity by analyzing the remaining chromatic structure. The application of Digital ROC certainly did restore the faded color. But I was not pleased with the slightly cool appearance of the preview image the dialog box.

My approach to color restoration in old color photographs is to leave the image with some hint of its age while restoring the colors to a more acceptable level. Since the skin tone was the critical element in this picture, I used the Red and Yellow sliders in Digital ROC to add a +5 tint to modify the automatic correction, which was too cool for my taste. The result gives the impression of an old photograph with good color, but without the predominant yellow cast.

The colors in this faded old print were restored using Applied Science Fiction Digital ROC. The dialog box (right) shows the program's automatic correction. The final image was warmed up a little.

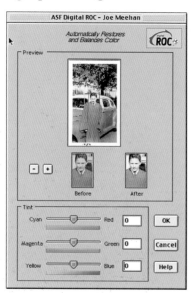

The Digital ROC and Digital SHO Photoshop plug-ins take a bit of time to apply their changes, but I do like the range of controls and the accuracy of the preview images. Digital ROC is also useful for removing a specific color cast and making color enhancements usually without significant increases in noise. It gives clean results with scanned images and digital captures I have tried.

Example 7: Eliminating Red-eye

(Software: Andromeda RedEyePro)

Red-eye is, unfortunately, a very common occurrence when working with any camera that has a built-in flash close to the lens axis, as on most point-and-shoot cameras. When shooting indoors and relying on the camera's flash for exposure, the typical result is the red-eye effect. The easiest automatic program I have tried so far to quickly deal with this is Andromeda RedEyePro. All you have to do is position the outline box over the colored portions of the subject's eye. As soon as the box covers the eye, the software automatically picks up the color and fills in the red areas while leaving the catch lights intact.

The dialog box has a choice of Novice (demonstrated here) and Expert modes. In Expert mode, additional refinements are possible, including removing colors other than red as well as changing the eye color.

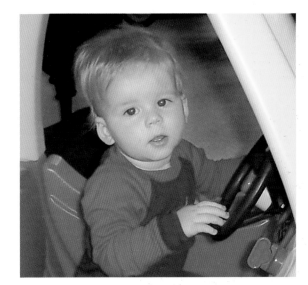

Point-and-shoot cameras can take great snapshots, but they are notorious for causing red-eye. Andromeda RedEyePro offers a quick fix for those glowing red pupils. Photo courtesy of Inge Grutzner.

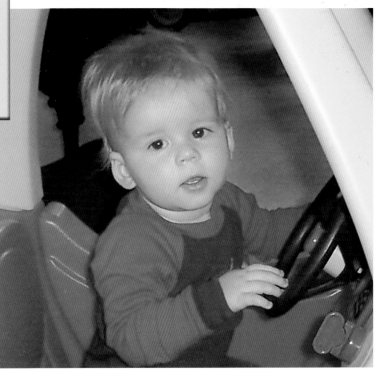

SPECIAL COLOR EFFECTS

Any photographer who has made a solarized or posterized print in a darkroom knows the feeling of watching their original image morph into some fantastic variation. The ability to make such changes with the click of a mouse in the digital darkroom of the computer is nothing short of amazing. Moreover, special effect software offers a host of other changes beyond what any conventional darkroom can provide. In addition, electronic special effects filtration is possible not only with programs designed for it, but also by pushing the adjustment controls to the limit with other programs.

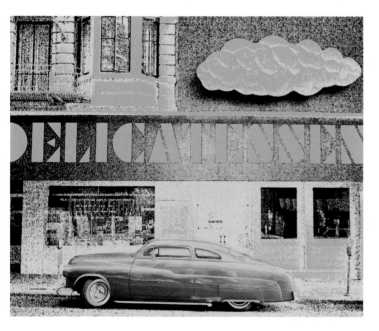

Example 8: Color Special Effects with Abstractions
(Software: nik Color Efex Pro, Adobe Photoshop)

It is very easy to produce a wide range of special effects using the Abstractions section of nik Color Efex Pro software. I have selected just four sub-categories in Abstractions to demonstrate here: Solarization, Stairs, Weird Dreams, and IR (Infrared Color). In general, the nik dialog boxes for these abstractions are very easy to use with intuitive controls for the effects offered by each category. The only challenge is trying to decide from among the many possible outcomes. The small sampling shown here should not be considered as the limits of what can be produced.

The picture of the vintage car and sign was originally shot for a culinary association. For the images on the left, Solarization and Weird Dreams were applied from the many nik Color Efex Pro Abstractions options.

Just two of the possible effects that can be created with Abstractions in nik Color Efex Pro: Solarization (top) and Weird Dreams (bottom).

Solarization and posterization effects can also be mimicked with Photoshop by manipulating the shape of the image curve in the Curves dialog box (Image> Adjust> Curves). Good results come when the curve is formed into a W or an S shape. A variation of this technique is to select only one of the RGB channels at a time and manipulate that curve separately. This can then be followed up with high settings of the Unsharp Mask filter. Applying it to a single channel or to each channel individually further enhances the solarization effect.

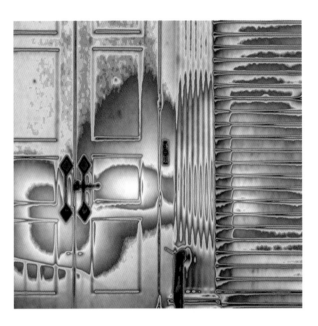

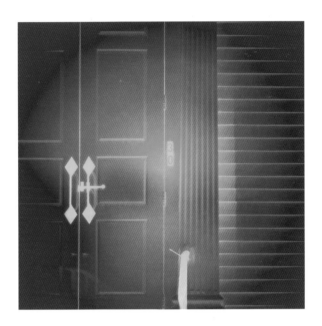

Stairs (left) and Color Infrared (right) effects from Abstractions were applied to the photos above.

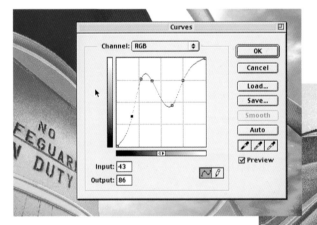

Solarization and posterization effects can be created by opening the Curves dialog box and manipulating the image curve.

Example 9: Artistic Filters

(Software: Adobe Photoshop)

For creative effects, Photoshop has an array of Artistic filters. The unmanipulated image is shown with the effects of Poster Edges below.

All versions of Photoshop have a number of filters that can produce interesting interpretations of an image. In this series, the original image from a 5 megapixel zoom-lens-reflex digital camera has been treated with a selection of Artistic Filters found in the Photoshop Filter menu (Filter > Artistic). Each filter has its own dialog box with specific ways to manipulate the image. These filters are capable of producing much greater changes than the rather conservative interpretations I have created for these examples.

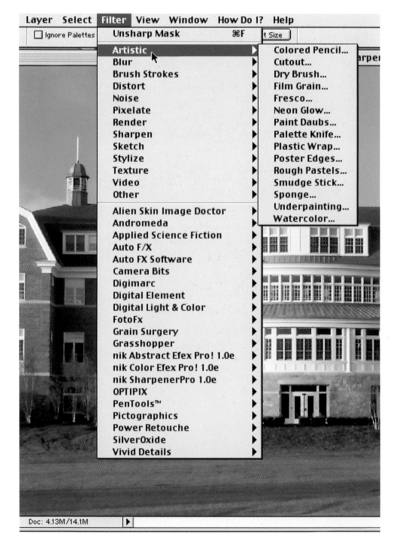

Document Your Experiments

If you like a particular special effect, be sure to write down each step or take screen-shots of each dialog box with the settings. (You can re-open the filter dialog box after checking the results on the original image, and the settings that were used should still be in place.) It is easier to precisely duplicate an effect if you know the sequence of operations and the exact numeric values that produced it.

Four more examples of Photoshop Artistic Filters
top left: Cutout
top right: Rough Pastels
bottom left: Watercolor
bottom right: Film Grain

SOFT FOCUS AND DIFFUSION FILTER EFFECTS

Chapter 3 discussed the variety of soft focus, diffusion, fog, and mist filters available today. In addition to the many camera filters, there are numerous digital effects that fall into these categories. Moreover, many of the effects available electronically are very different from what can be done by any camera filter.

near right: The unfiltered test image.

bottom: The dialog box for Andromeda ScatterLight software.

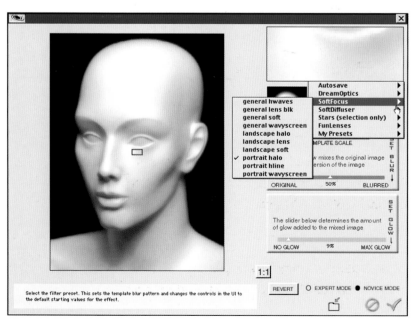

Example 10: Soft Focus and Diffusion Filter Effects

(Software: Andromeda ScatterLight, Auto FX's DreamSuite Bonus, Adobe Photoshop)

One of the most versatile programs for producing a whole array of soft-focus effects is the Andromeda ScatterLight program. As a matter of fact, you could spend a week at your computer exploring the whole range of possible results and still not exhaust the number of effects that this program can produce. Thus, the examples I have shown here are just a very limited sampling.

The selection of different effects in ScatterLight begins with a choice of seven main categories. After you select the main category, anywhere from two to ten additional subcategories become available. In addition, you can control the amount of Blur and Glow for each of these settings.

above:
On the left is an example of Fixed-Fog Noise from the ScatterLight SoftDiffuser category with 30% glow and 50% blur. The image on the right used the DreamOptics category from Andromeda ScatterLight. The effect applied is "Dream f056" at 0% glow and 50% blur.

on the opposite page:
Two samples from the Andromeda ScatterLight SoftFocus category. The top image shows "Portrait Wavy Screen" and the bottom uses "General Lens BLK." Both used 0% glow and 50% blur settings.

Another program with interesting though more limited soft-focus effects is Auto FX DreamSuite. In addition to a range of soft focus and diffusion effects, this program can also add a color tint to an image. It can be adjusted to mimic the warm effect found in warm soft-focus camera filters.

Finally, there is the popular Gaussian blur filter in Photoshop (Filter > Blur > Gaussian Blur). Many photographers use this filter to soften the features of portrait subjects, particularly women.

right: The Auto FX DreamSuite dialog box.

bottom left: A strong soft focus effect with color tint produced with Auto FX DreamSuite.

bottom right: A subtle application of Photoshop Gaussian Blur.

REPRODUCING THE LOOK OF FILM

In the film versus digital photography debate, the point is often made that film has a different look than a digital image. Indeed, one distinction that sets a digital image apart from a film image is the lack of a grain pattern. Granted, noise in a digital image may resemble grain, but there is a difference especially in larger prints. Furthermore, specific films have different characteristics that give them a unique way of rendering a subject.

A handful of specialized programs offer effects that emulate the look of film in a digital camera image. Some programs create the look of film by introducing a grain pattern. In addition, some of these programs can also decrease graininess in a scanned film image. Digital GEM from Applied Science Fiction and Grain Surgery from Visual Infinity are two examples of software that offer this feature.

Example 11: Filtering to Add Grain
(Software: Alien Skin Image Doctor, Visual Infinity Grain Surgery)

Both filter programs illustrated in this example are good at simulating either color or black-and-white film by adding realistic grain patterns. The effects and controls differ from program to program, making a wide variety of results are possible.

The original image was photographed with a 6 megapixel digital SLR with a 24–85mm zoom lens at 24mm. First Alien Skin Image Doctor was applied. There is an Add Grain option as part of this program's JPEG Repair function. The JPEG Repair dialog box was opened and a maximum Add Grain effect was added along with the maximum setting on Remove Artifacts. When printed on an ink jet printer at 8 x 10 inches or larger, the nice, tight grain pattern makes the image look like it was shot on an ISO 100 film.

Film grain was simulated for this digital capture using two different Photoshop plug-ins.

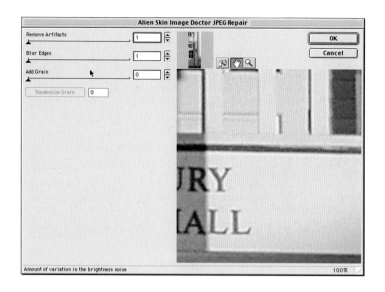

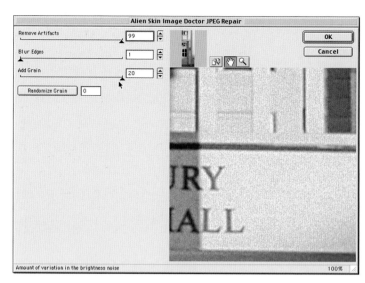

The preview window in the JPEG Repair dialog box shows the image before a grain pattern was added.

In the preview window, the effects of the Add Grain and Remove Artifacts settings are apparent.

The second example comes from Grain Surgery, a sophisticated program from Visual Infinity that gives the user many options for removing grain, creating grain, and matching grain. The preview image is accurate and the program has a good deal of flexibility. A specific film type can be selected from the Presets list and the software dials in the appropriate settings for Grain Size, Intensity, and Saturation (for color only). If you would like to tweak the results, you can switch to Custom and alter the settings until you get the look you want.

Example 12: Altering Depth of Field

(Software: Andromeda VariFocus)

The VariFocus software from Andromeda is one of those programs that you have to sit and play with for a while in order to appreciate it. It is not really a "one-click" operation, but its potential for unique results makes it worth exploring. Basically, the program allows the user to defocus portions of an image using different patterns to control where the effects occur. This produces an effect similar to using shallow depth of field as a way to isolate a subject. Varifocus goes beyond simple depth of field defocusing;

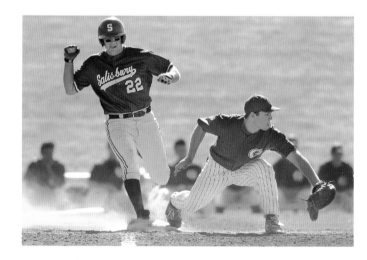

This baseball shot was taken with a 400mm lens on a digital SLR at ISO 800.

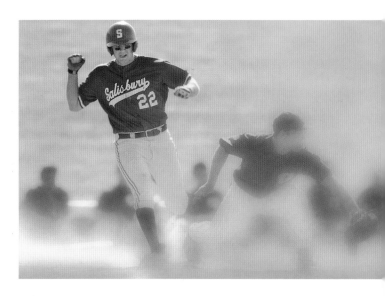

The dialog box for Andromeda Varifocus

This runner rounding the bases was isolated with Andromeda Varifocus.

extending the defocus effect produces a more graphic result. The VariFocus dialog box gives many pattern choices that control where the effect occurs in the picture. Sliding scales then determine the size of the pattern and how much of a defocusing effect will occur outside that pattern.

Example 13: Perspective Correction

(Software: Grasshopper ImageAlign)

Whenever a camera is tilted upwards at a tall subject like a building, straight, vertical lines will appear to converge. This type of perspective distortion is called the keystone effect. SLR users have the option to correct for this effect by using a Perspective Control (PC) lens. This specialized lens is designed so that the optical elements shift to frame a tall subject without having to tilt the camera. As long as the film plane of the camera remains parallel to the plane of the subject, the lines will remain straight and parallel. With the front portion of the PC lens raised, the camera does not have to be tilted. When the front is not moved upwards, a PC lens performs just like a conventional lens.

Certain programs, such as Andromeda LensDoc and ImageAlign by Grasshopper, are designed to perform perspective corrections. Of the programs that I have tried, ImageAlign is the easiest and has a very accurate dialog box. Six controls are available. Two are for perspective correction: either horizontal or vertical. Two controls handle correction optical barrel and pincushion distortion. In barrel distortion straight lines bend outward while pincushion distortion causes them to curve inward. There are also rotation and scale controls. Grid lines can be laid down over the preview image to help determine the amount of correction needed. Adjustments can be made with sliders or numerical settings.

In general, PC lenses and perspective control software will result in the loss of some of the image area. With a PC lens, the photographer can adjust the composition before taking the picture. This is more difficult when digitally manipulating an existing image. Consequently, if you plan to use perspective correction software, be sure to allow some additional framing area on the sides of the composition. In the example of digital correction for the keystone effect, the area lost was on the right and left sides.

This photo was taken with a 28mm PC lens without any correction. The camera had to be tilted up at about a 30-degree angle.

Instead of tilting the camera, the front portion of the lens was raised to include the whole building in the frame. This eliminated the keystone effect.

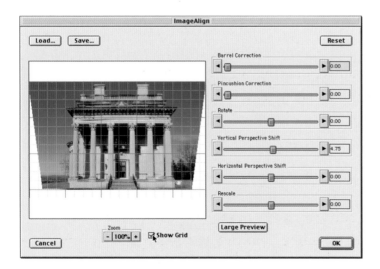

The Vertical Perspective Shift slider was adjusted until the straight lines of the building's columns were parallel to the vertical grid lines.

The results of using a correction setting of 4.75 to produce the same degree of change as seen in the photo taken with the PC lens.

NOISE REDUCTION PROGRAMS

In Chapter 3, I touched briefly on the subject of digital camera noise using generalizations that really belie the complex nature of this phenomenon. For example, long exposures, in-camera image processing software, the production of heat in the sensor, as well as lighting contrast and intensity can all be factors that contribute to image noise. In addition, most photographers are more interested in ways of reducing the presence of noise to improve the appearance of an image than in the technical complexities of this subject. To get a better idea of how complicated the issue of digital noise is, I suggest reading an interesting white paper available from nik Multimedia entitled "Effective Noise Reduction & Detail Optimization," available for downloading at the nik Multimedia website. (See Appendix 2)

The best overall approach for dealing with noise is to avoid conditions that produce noise at the capture stage. In addition, it helps to be aware of the procedures to follow if a noise reduction program will be employed. Here is a list of some things to consider when shooting with a digital camera:

• Using long exposures or shooting in low light are more likely to produce higher amounts of noise. Consider using a electronic flash or other main light instead of weak available light. Some of the "cleanest" images come from using large light sources, for example, a strobe with a large soft box or umbrella.

• If your camera has a setting for increased contrast, it is likely to make noise levels more prominent. You can adjust contrast more effectively in the computer than with the camera's software. In this regard, the RAW file format is very useful if offered by the camera.

• The use of the JPEG file format will likely produce additional unwanted information called artifacts. Use either TIFF or RAW file captures to avoid this additional problem.

• Sharpen your images in the computer, which gives you greater precision, rather than using the camera's overall sharpening function.

• If you are going to use a noise reduction program, consider applying it selectively rather than over the whole image. Use it only in the areas that need it most, while leaving acceptable portions of the image untouched.

•Some noise reduction programs recommend turning off optional in-camera noise reduction functions. This allows the specialized software to work as a first application.

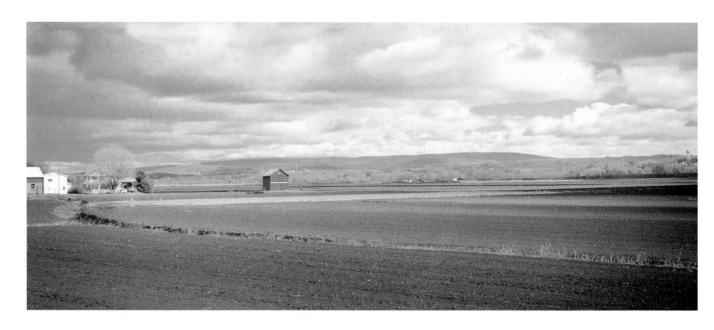

This farm scene required a great deal of color and contrast manipulation. The resulting noise is quite apparent in the enlarged section of the image below. (photo: Barbara Wylie)

There is also the problem of "software noise" or an increase in noise as a result of using filter software (mentioned on page 90). The photo above is an original scan of a color negative from a point-and-shoot camera that has been altered with a number of filter programs. The adjustments were extreme enough to produce the unwanted extra data seen in the enlarged section of the photo. I have found that noise reduction programs are more successful at treating digital camera noise than reducing software noise.

While noise reduction programs can certainly be of help in removing the unwanted signals, none are magic wands that always solve the problem completely. Reduce rather than eliminate would tend to characterize most successful results. In my experience, this reduction is enough to obscure the obvious effects and produce a significantly cleaner print. I have also found that working with these programs to extract their maximum effect takes time. While the program may have a simple point-and-click operation, it is often worth trying different treatments on the same image.

As a generalization, noise produced by digital cameras takes two forms: chrominance and luminance. The former looks like tiny colored bits of data randomly scattered (usually in a dense pattern) within an image while the latter usually resembles less densely scattered black "grain." I look at the work of noise reduction programs as producing two basic changes. Either they mitigate the chromatic effects and/or they blur the image slightly so that the fine detail of noise becomes merged into the body of the image.

In general, I have found that a moderate amount of noise in a digital file does not become a problem until the image is blown up beyond the size of a typical 4 x 6-inch (10.2 x 15.2cm) snapshot from a high quality 1449- or 2880-dpi desktop photo ink jet printer. In other words, to output an 8 x 10-inch (A4) print, noise has to be controlled, otherwise it becomes a noticeable texture in the print. I routinely examine images in the computer at 100% to evaluate the level of noise. If noise is obvious at that magnification, I apply a degree of noise reduction and then consider how large I can print the image based on how much noise can be removed. This workflow is, of course, a personal one. Each photographer has to set his or her own standards when determining unacceptable noise levels.

Example 14: Noise Reduction

(Software: Quantum Mechanics Pro, Alien Skin Image Doctor, nik Dfine)

The image shown below is an enlarged section of a white building in shade taken just after sunrise. The image is underexposed, and there is a blue color cast to the JPEG file as well as chrominance due to the shooting conditions.

The test photo for this example is an enlargement of a building's white wall. The JPEG capture was made at sunset with a 2.0 megapixel digital camera.

An enlarged section of the test photo with no image adjustments shown in the Quantum Mechanic Pro dialog box.

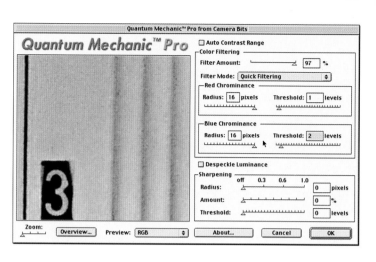

The program's red and blue Quick Filtering has made the chromatic artifacts less pronounced without significant image blur.

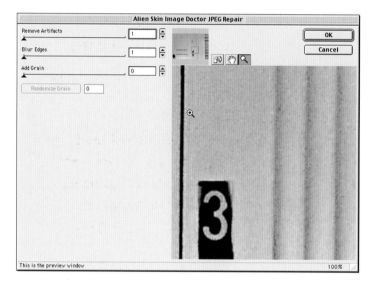

An enlarged section of the test photo with no image adjustments shown in the JPEG Repair dialog box.

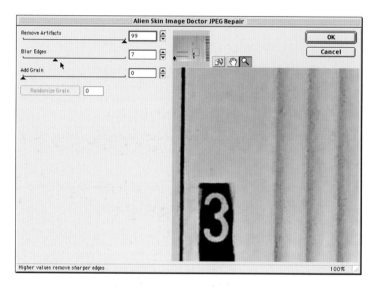

The result of adding a maximum amount of color reduction and about a third of the maximum blur with JPEG Repair.

Quantum Mechanic Pro is a noise reduction program I rely on frequently to remove chromatic artifacts. The dialog box of this software has a good preview image with the ability to zoom. The user has a great deal of image control. In the test image, the program's Quick Filtering feature made the unwanted chromatic artifacts less apparent without adding blur.

Another noise reduction program is Alien Skin Image Doctor. I have used the JPEG Repair feature within this program with good results although it gives the user fewer control options than Quantum Mechanic Pro.

A program I was able to use for just a few days before the deadline for this book is Dfine by nik Multimedia. This unique and sophisticated program is designed with specific profiles for different camera models and ISO settings. The reasoning here is that while digital cameras share similar sensors, different models vary in the way they process information. Therein lies a major problem for the designers of noise reduction software. Corrections for the noise characteristics of one camera may not be the optimum method for dealing with the images from another camera model. According to nik Multimedia, using individual camera profiles allows the program to be very specific in the way it applies corrections.

While I had only a limited period of time to get to know Dfine, it is clear that this program represents a whole new level in noise reduction software. In addition to identifying the type of noise to be treated, it also separates out key tonal areas for alteration, as well as considering contrast and other factors. This program also gives plenty of options for identifying the characteristics of the type of noise in your image. Dfine has a learning curve and you will have to spend time getting to know what it can do. I believe it is well worth investing the time for the results that this software can produce.

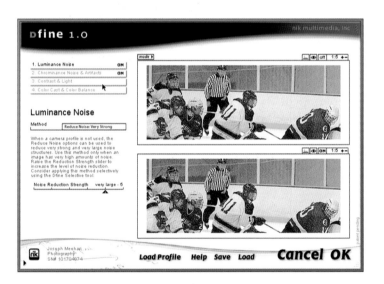

Dfine from nik Multimedia is sophisticated software that offers many ways to deal with the problem of image noise. The program's camera profiles provide optimum noise correction for specific camera models and ISO settings.

Before using nik Dfine, this image captured with a digital SLR at ISO 1600 was very noisy.

This photo shows the ability of Dfine to clean up extreme image artifacts.

Black-and-White Filter Techniques

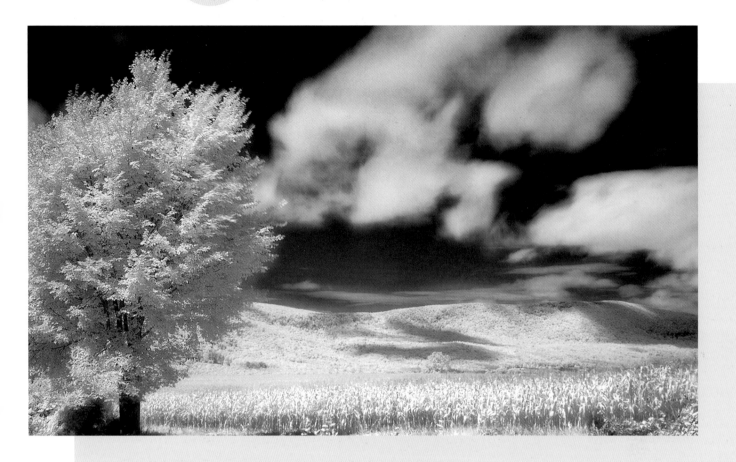

Viewing the world in black and white reduces everything to the most simple and yet most mystical qualities of light.

This final chapter is concerned with the various methods for using camera and computer filter techniques to produce black-and-white images. First, the use of camera filters for black-and-white photography are discussed. Then, software effects are covered. As in the previous two chapters, the method of presentation demonstrates specific techniques using "before-and-after" examples.

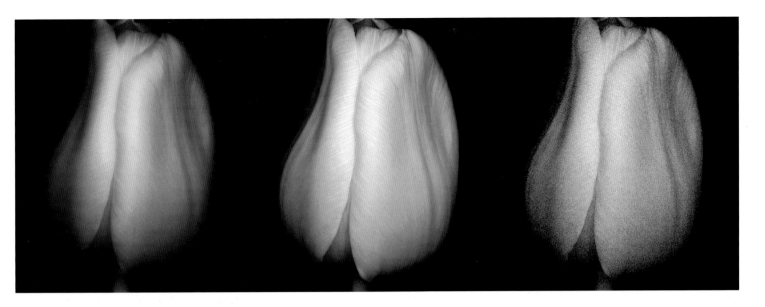

BLACK-AND-WHITE PHOTOGRAPHY

A black-and-white photograph is certainly the most elemental form of photography with its basic language of black, white, and various shades of gray. Yet despite these simple components, some of the most profound and striking images ever made have been in black and white. Additional processes can extend its creative range, for example, adding color with sepia and selenium toning (to name just two toners). There is also the time-honored practice of hand coloring. And don't overlook the unique effect that infrared black-and-white photography produces; white trees appear to shimmer in stark contrast to jet-black skies.

Early on, black-and-white photographers learned to refine the tonal range of this medium using strong colored filters. Following the principle of subtractive filtration, these filters increase or decrease the density of the gray tones representing individual colors in a scene. This ability to render a specific color as a lighter or darker gray tone provides separation within a scene. Differences in contrast create a much richer, more visually interesting print. These filters are referred to as black-and-white contrast filters.

While digital photography has been primarily concerned with the use of color, there has been a steady increase in the use of digital methods to produce high quality black-and-white images. Advances in the quality of ink jet printers and monochrome ink sets are driving this interest. Today, a photographer using digital methods can make beautiful monochrome prints with his or her desktop printer using a variety of papers and inks.

There are several ways to produce black-and-white digital images. Film or prints can be scanned. If the images are color, they can be converted to grayscale. Another choice is to take the picture with a digital camera in either the grayscale or color mode. Again, the color image would be converted to grayscale in the computer. Many photography chat rooms have heated up with conflicting opinions over which one of these approaches is best. Since many photographers continue to shoot film, this chapter begins with a section on using camera filters with film.

BLACK-AND-WHITE CONTRAST FILTERS

The same subtractive principle is at work in black-and-white photography as with colored filters in color photography. The filter allows like colors of light to pass while all others are absorbed to some degree. Light that is complementary to the filter color is absorbed the most. The denser the filter is, the greater the absorption.

One of the most popular filters for black-and-white photography is the Yellow 8 for its ability to help separate clear blue sky areas from white clouds. Black-and-white films characteristically render clear blue skies as light gray or white. The yellow filter absorbs some of the blue light; essentially the sky area receives less exposure. The result is a noticeably darker sky, increased contrast between the sky and clouds, and greater separation of these two visual elements. If a stronger complementary filter is used, such as a Red 25, the darkening of the sky area will be greatly increased and with it the contrast of the scene.

The same principle applies when shooting with a digital camera in the grayscale mode. With a yellow (or red) filter in place, some blue light does not reach the camera's sensor. Consequently, that area will appear much darker in the final image. In general, a digital camera in grayscale mode will have a similar response to contrast filters as black-and-white films. However, there are some differences in color sensitivity between black-and-white films and digital sensors. For example, films are more sensitive to UV light than digital sensors.

first row: Blue 47, Orange 21
second row: Yellow 12, Yellow 8
third row: Green 58, Green 11
fourth row: Red 23, Red 25

To produce a noticeable effect, black-and-white contrast filters must absorb a large percentage of a particular color of light. This is why they are so strongly colored. The Yellow 8, Green 11, Orange 21, and Red 25 are the most commonly used contrast filters. All are available in a wide range of sizes and materials.

Many digital photographers prefer, however, to capture an image in color and then do a conversion to black-and-white in the computer, adjusting contrast as desired. The reasoning is that a color file contains more information and the option to alter the color translation after the capture gives a greater degree of control.

The counterargument is that shooting in grayscale mode with a filter gives the photographer immediate feedback as to how tones are going to be rendered. This information could cause the photographer to change the composition on the spot to exploit an effect that the filters have revealed.

The Effects of Black-and-White Contrast Filters	
Filter	**Effect**
Yellow 8 and 12	Produces more natural landscapes by separating yellow, orange, and red coloration from blue.
Green 11	Eliminates yellow/brown stains and some haze, produces slightly lighter green foliage, more natural skin tone with light skinned subjects.
Green 58	Separates green tones and makes them lighter, produces ruddy skin tones under tungsten light.
Orange 21	Penetrates haze, darkens greens and blues and lightens orange and yellow, for example in flowers and autumn foliage.
Red 23 and 25	Strong haze penetration, dark rendering of green foliage, gives light-skinned persons a washed out look with light colored lips, darkens light wood furniture, produces dark, ominous skies.
Blue 47	Increases contrast of blue prints and faded yellow prints, produces darker skin tones under daylight/flash, turns blue skies white.

Example 1: Choosing a Camera Filter

(Black-and-white reversal film with black-and-white contrast filters)

The picture below of the colorfully painted entranceway and stairwell is as a good example of the ability of contrast filters to separate different tones in a black-and-white photo. The composition is made of two main parts: the yellow stairs and the blue entranceway that frames the stairs. An Orange 21 filter rendered the blue entranceway darker and the yellow stairs lighter. Next, I wanted to produce an even more dramatic separation between the yellow stairs and the blue wall while reversing the tonal values. A Blue 47 filter produced a very light rendering of the entranceway combined with a darker tonality for the stairs.

Contrast filters are excellent for building tonality in areas that would otherwise appear white or light gray. Sky areas benefit greatly from the use of contrast filters. I use several filter combinations as summarized in the chart on page 144, "Controlling Sky Contrast with Filters," to determine how the skies are rendered. The sky goes quite dark when a

When photographed in color, this scene has vivid contrast between the warm yellow stairs and the bright blue door frame.

The black-and-white version looks very flat by comparison when no filtration is used. The colors appear as similar shades of gray.

Red 25 filter is used. Even more dramatic is the "black sky" effect that results from using a Polarizer and a Red 25 filter together. The intensity of the effect will depend on whether or not that section of the sky will show a full polarizing effect, as explained on page 47.

Significant attention should be paid to sky areas in any setting, but they are particularly important in landscape images, since this area often amounts to as much as one-third of the whole scene. A moderately dark sky that contrasts slightly with the white clouds may be more appropriate than a dramatic black sky. It all depends on what the rest of the scene needs for the most balanced presentation. Black-and-white contrast filters provide the means to achieve such a balance.

Photographing the scene through an Orange 21 filter lightened the stairs and darkened the blue doorway framing the scene.

Using a Blue 47 filter had the opposite effect, darkening yellows and oranges and making the blue tones lighter.

Without any filtration, a blue sky would appear very light gray in a black-and-white photo. Using a Red 25 filter (left), rendered the sky as dark gray. Adding a Polarizer to the Red 25 filter (right) made the sky almost black.

Controlling Sky Contrast with Filters

Desired Effect	Filters
Slight darkening	Yellow 8 or 12*
Moderately dark	Polarizer* Orange 21* Yellow 8 or 12 and a Polarizer*
Very dark	Red 25
Black	Red 25 and a Polarizer

* A graduated 0.6 or 0.9 neutral density filter can be added to produce a gradient effect.

FILTER EFFECTS IN BLACK AND WHITE

Chromatic Filters

The effects of contrast filters are maximized if the color being filtered is pure. Thus, a filter test that uses a color chart as the subject will show the most extreme results possible. Most colors in the "real world" are actually mixtures, so you may not achieve the same degree of change as with pure colors. Just think of the different variations in red apples, even those of the same variety. Also, the most dramatic shifts in contrast occur when the subject is in bright light. If the subject is in shade, the degree of change produced by the filter will be significantly less, or in some cases, may not even be noticeable.

Non-chromatic Filters

The results produced in black and white by certain non-chromatic filters may not parallel the results in color. For example, a soft-focus filter may lower contrast in black and white but not do so in color. Why? Because perceived contrast in black and white is based on a sharp line of separation between the specific shades of gray. If that line of demarcation between tones is softened, it appears that a degree of contrast is lost. This can occur even though the two areas have not really changed in density.

COLOR TO MONOCHROME SOFTWARE CONVERSIONS

Converting a color image to monochrome in the computer and then applying the digital equivalent of contrast filters can be done easily by using several different programs. Before considering filtration, look at some simple ways to convert them from color to black and white.

Example 2: Converting from Color to Monochrome
(Software: Adobe Photoshop)

In Photoshop there are several ways to change a color image to black and white. An image can be converted by changing the Mode to Grayscale (Image > Mode > Grayscale). However, Grayscale Mode discards the color information in a file. Consequently, a filter program that emulates contrast filter effects cannot be used on a grayscale file. On the other hand, the Desaturate command (Image > Adjustments > Desaturate) gives the appearance of a grayscale image while preserving the color information in the file. In both cases, the image manipulation program controls the way colors will be translated initially.

top left: This photo of a family outing was captured with a digital camera.

top right: The image was converted to black-and-white using the Photoshop Desaturate command.

bottom right: A similar look is obtained using Grayscale mode, however, the file's color information has been discarded.

 The family fun shot shown here was taken with a 3.1 megapixel point-and-zoom digital camera using fill flash. Both black-and-white conversions were created with Adobe Photoshop using the Desaturate command and the Grayscale Mode.

 The unique architectural photo on the opposite page was taken with a Widelux 120 camera for a cover story on panoramic cameras I did in *Popular Photography* magazine several years ago. The off-registration effect was produced by making a positive film mask and sandwiching it with the transparency. The same treatment given to the family photo was applied to this image. The two black-and-white versions were created with Photoshop's Desaturate command and Grayscale mode. These quick color to black-and-white conversions work equally for scanned images and digital captures.

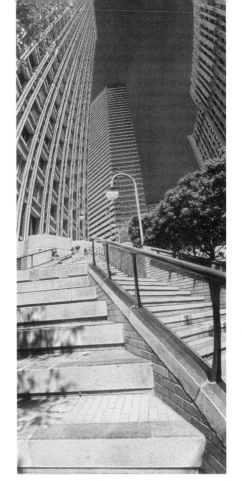

This panoramic photo, originally shot on color reversal film, was converted to black and white using Desaturate (top right) and Grayscale mode (bottom right).

Example 3: Channel Mixer Conversion Method

(Software: Adobe Photoshop)

The ability to control the translation of colors into tones rather than just accepting what is done automatically with the Desaturate command represents a decided advantage. Using the Channel Mixer function of Photoshop to make black-and-white conversions from color images is an easy way to have control over the tonalities of certain colors. The original color image shown in this example was taken on transparency film with a panoramic camera. It was initially converted by opening the Channel Mixer (Image > Adjustments > Channel Mixer) and checking Monochrome in the dialog box. A rather dramatic rendering was created with the channels set as follows: Red +100%, Green 0%, Blue 0%. A less dramatic conversion was made by almost equalizing the Red Channel and Green Channel values while leaving the Blue channel at 0%.

The theory behind this approach is that the values for the three channels should add up to about 100% but I have found this does not necessarily produce the desired result. However, exceeding a total of 100% may introduce an unacceptable level of image noise.

This scan of a panoramic photo was selected to demonstrate the use of Photoshop's Channel Mixer for black-and-white image conversion.

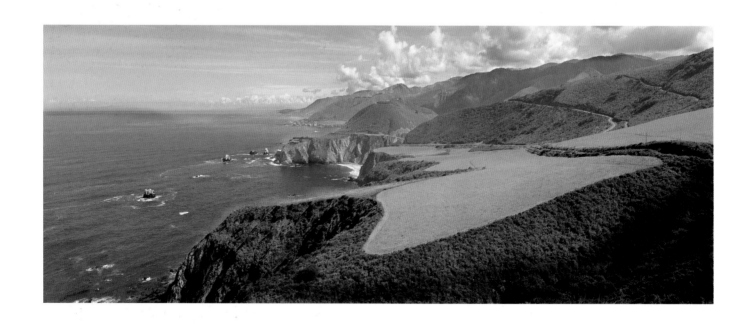

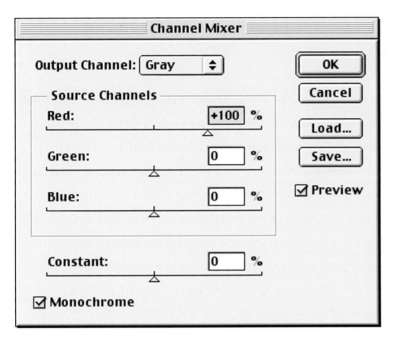

top left: Photoshop's Channel Mixer gives the user control over tonal reproduction. When the box marked Monochrome is checked, the image is shown in black-and white. The sliders can then be adjusted to alter shades of gray in the image.

center: Checking the Monochrome box produced this effect. The red slider was automatically set at 100%.

bottom: Balancing the green and red sliders decreased the contrast.

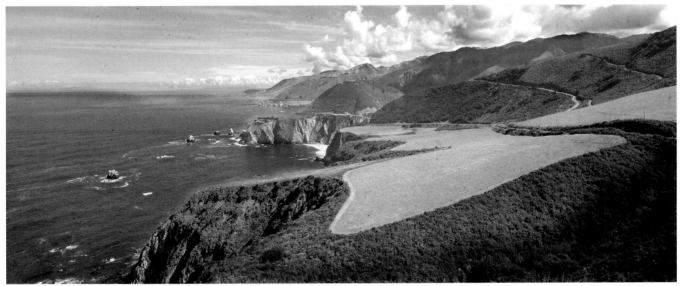

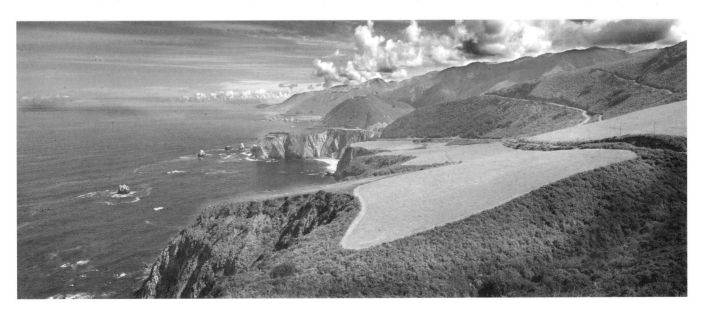

Example 4: Monochrome Conversions with Contrast Filter Effects Software

(Software: nik Color Efex Pro, Pixel Genius PhotoKit, Fred Miranda Actions, Silver Oxide)

In this example, the goal was to emulate traditional black-and-white photographs made with contrast filters. Three filter colors were selected: yellow, orange, and red. These three filters produce the highest levels of tonal separation with warm autumn colors. Four different software programs are demonstrated. This illustration is not meant as a test to compare qualities of the four programs. Rather it is intended to give you some idea of how the programs differ in terms of the controls provided as well as the layout of their respective dialog boxes. Interestingly, with the exception of Silver Oxide, none of these programs identify their filter effects using the nomenclature of camera filters, for example, Yellow 8 or Red 25. Instead, filters are identified by color only.

PhotoKit Color to B&W Set offers a selection of contrast filters that are accessed with a pull-down menu. The strength of each filter effect is not variable. Instead, the intensity is chosen in incremental steps, such as Deep Red and 1/2 Deep Red. A Deep Red filter conversion was applied to the sample image.

This is the unaltered test image used to demonstrate black-and-white conversion and filtering options with four different programs.

Silver Oxide software has a unique feature that provides for digital conversions that mimic the look of certain black-and-white films. In other words, you can purchase a version of this program to replicate the characteristics of a specific black-and-white film. You then have a choice of three specific camera filter effects: Red 25, Yellow 8 and Green 11. There are also separate controls for gamma and brightness with numeric settings, which make it very easy to record and reproduce results.

Like most of Fred Miranda's offerings, Digital B&W Pro Photoshop Actions offers the user many controls. The black-and-white conversions work through Photoshop's Channel Mixer, which is opened when a filter is selected. This package presents several other interesting Actions, such as a 400-speed film simulation and a correction for low-contrast files.

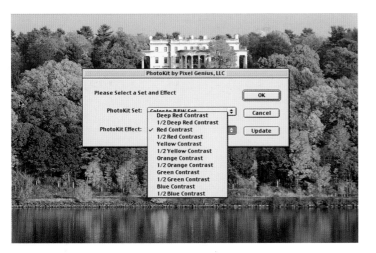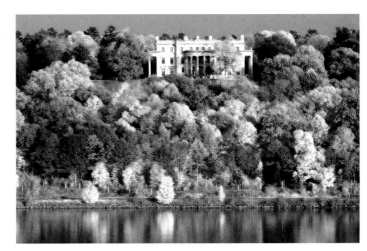

PhotoKit from Pixel Genius is a Photoshop plug-in. Users choose a filter from a list in a pull down menu and the image is converted to black and white. A Deep Red filter produced this strong effect.

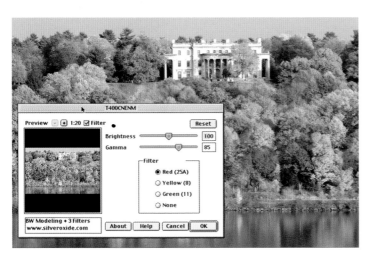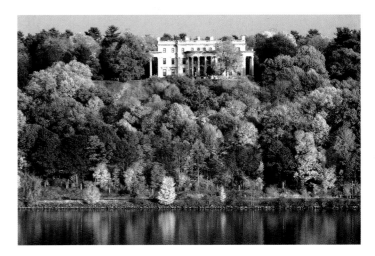

Silver Oxide converts images to mimic the look of specific black-and-white films and applies filtration. This photo shows the effect of a Yellow 8 filter conversion.

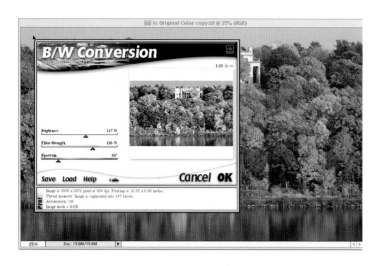
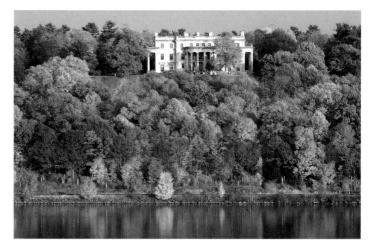

The dialog box for nik Color Efex Pro uses sliders to control which color is selected, the strength of the filter, and image brightness. The photo on the left shows the effect of an orange filter.

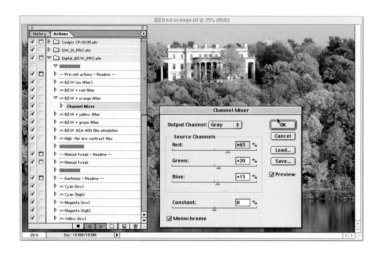
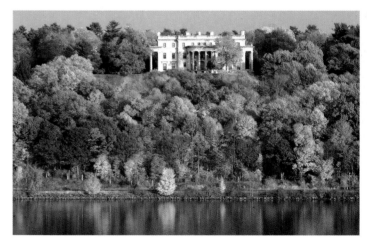

Fred Miranda Digital B&W Pro Photoshop Actions loads the Photoshop Actions menu with automated settings for making black-and-white conversions. In this example, an orange filter was applied.

TONING BLACK-AND-WHITE IMAGES

There is a long history in traditional photography of adding color to black-and-white prints. There are a number of image-manipulation programs that include this function. Some have preset tones while others allow the user to set values on a sliding scale. Actually, any software program that provides individual controls over the color balance of an image can produce an effect that emulates a black-and-white toned image. Some programs offer the option of going from a full color image directly to a toned black-and-white look. I get better results by first desaturating the color image and applying contrast filters to get the desired tonal separation. Then, I consider color toning to finish the image.

Keep in mind that all these programs require a color file to produce these effects. If you are starting with a black-and-white negative or print, save the scan as an RGB file. Do not convert it to Grayscale.

Example 5: Toning Black-and-White Images

(Software: Power Retouche, Silver Oxide, FotoFx MonoToner)

Power Retouche software is a good example of a program that provides a selection of preset color tones for black-and-white images. The demonstration photo has been treated with four of the automatic presets that are located in the lower right hand corner of the Power Retouche dialog box. Any of these presets can be fine-tuned by moving the sliders in the Tone Grayscale section, which also uses numeric values for easy replication of effects.

Another program that offers presets is the Silver Oxide Sepia Toning Filter. Although the name is misleading, this plug-in has four toning color options: brown, yellow-brown, blue, and lavender. This program applies effects to 16-bit color files whereas other programs are commonly limited to 8-bit files.

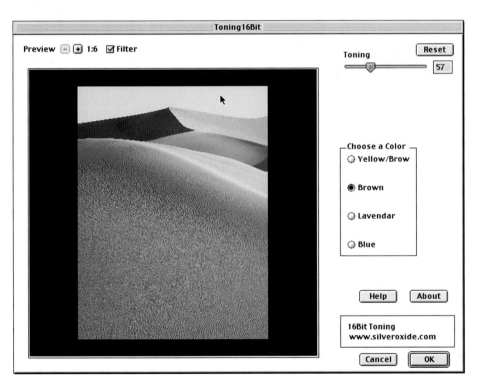

This sand dune in Death Valley was originally shot in color. The file was desaturated and then, from the Silver Oxide dialog box, two treatments were selected: Brown and Lavender. For each an intensity of 57 on the Toning scale was applied.

There is also a very straightforward program called FotoFx MonoToner that allows the user to set the color at any point on an extensive scale. This program will give you a wide range of colors and effects. There is also the option to use Applied Science Fiction Digital ROC or Photoshop's Color Balance function and adjust the color sliders. With these programs, colors are all changed independently; experimentation is required to produce a specific effect. Programs with presets have the advantage of "point-and-click" ease.

Multi-color toning, as seen in the photo of the car in front of the delicatessen on page 156, is accomplished by selecting certain parts of the scene and applying color. Still another variation is to select a portion of an image to remain in full color. The balance of the image is then desaturated or colored with a single tone. Yet another option is to use the toning functions available when a print is made on a desktop ink jet printer. For example, certain Epson printers have a Sepia option, which alters the ink mix to produce this traditional tone. Also, there are toned monochrome ink sets such as those from Luminous/Lumijet, MIS Associates, Lyson, and MediaStreet.com. (See Appendix 1 for contact information.)

top: To demonstrate Power Retouche, four of the program's toning presets were applied to this image.

left: The Power Retouche dialog box includes controls to convert an image to black and white, add a contrast filter effect, and apply a color tone.

Power Retouche Van Dyck Preset

Power Retouche Cyanotype Preset

Power Retouche Platinum Preset

Power Retouche Sepia Preset

Multi-toning is accomplished by selecting certain parts of the scene and applying color. Increasing the color's opacity can produce results that resemble handcoloring.

To emphasize the football player facing the camera, the players around him were desaturated and then colored with a slight warm tone.

INFRARED PHOTOGRAPHY WITH DIGITAL CAMERAS

All digital cameras are sensitive to the visible spectrum of light ranging from 400-700nm on the electromagnetic spectrum. In addition, digital camera sensors may also be sensitive to the near infrared (IR) spectrum between 730nm and 1200nm.

In order to produce a full infrared image, the capture must be dominated by infrared light. For example, the very strong Red 25 and Red 29 filters allow all of the red and infrared light through but only a small amount of green and blue. Typically, with a digital camera that records infrared light, this produces a high contrast scene. Sometimes the rendering will give a "pseudo infrared" look, especially when a soft-focus filter is added. True IR images require the use of even stronger cut-off filters that block all or almost all visible light. This will produce the characteristic infrared look with black skies and white foliage, often with an ethereal, soft glow.

An infrared photo of St. George's Courtyard, Bermuda, © Theresa Airey

The most popular IR filters for black-and-white digital infrared photography are the 87- and 89-series filters. The 87 filter completely cuts out the visible light spectrum and allows a significant amount of infrared light beginning at about 760nm, where approximately 13% transmission occurs. On the other hand, the 89B filter allows a small amount of visible light through at 690nm. Most of these filters are available as round glass types in a range of sizes as well as gels.

Avoid Light Leaks

It is extremely important to make sure the IR filter completely covers the lens. Using a threaded round filter produces the best fit. I have also used a rigid bracket-type IR filter fitted to the lens. Problems with light leaks can come when you are hand-holding a filter and the filter is not completely flat against the lens. Also, trying to hold a flimsy gel filter in front of the lens invites light leaks. If the fit is not absolutely tight and some visible light gets through, the image will have light fogging streaks or "bleached out" white areas. Shield the lens with a lens hood as an added precaution.

Successful digital infrared photography will depend on whether or not the camera manufacturer has installed materials that block infrared light. Some cameras have a "hot mirror" in front of the sensor, which transmits visible light while blocking infrared wavelengths. This effectively prevents full infrared recordings, although you may still get a low-level infrared image.

Regardless of how good the exposure for an infrared capture, you will usually need to adjust the brightness and contrast levels in the computer. Infrared images have very low contrast, especially when an 87 filter is used. The results can be seen in the camera's LCD screen, but my experiences with several cameras indicate that the LCD is only a fair indicator of whether or not you have a good IR exposure.

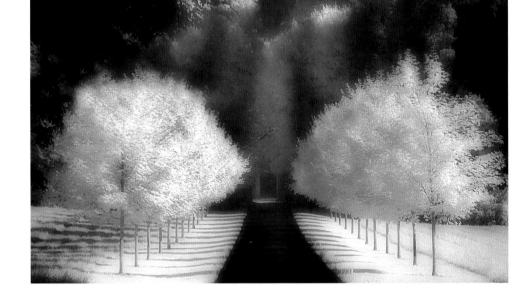

Green foliage reflects a significant amount of infrared light. It typically appears very pale or even white in photos.

Infrared imaging usually requires slow shutter speeds, which can result in motion blur. This is not necessarily bad. It can add to the ethereal look of this process.

The key to really impressive infrared photography is to shoot when there is plenty of infrared radiation present. Prime conditions occur when the sun is high in the sky and is not blocked by clouds. Shooting when the sun is low is great for producing three-dimensional shadow areas with panchromatic films. In digital infrared captures, however, these shadow areas often record as solid black with no detail. Also, without direct sunlight, the infrared effect is diminished and the scene takes on a muddy appearance.

When shooting infrared images be aware of subject motion and work with a tripod. Slow shutter speeds—several seconds or longer—are not uncommon. Infrared digital images often show evidence of the slow shutter speeds that are required. Trees branches may have an obvious motion blur. Even if there does not seem to be any wind, be aware of how fast the clouds are moving since they may blur as seen in the picture on page 138. It is also a good idea to use a cable release or set the camera's self-timer to prevent camera shake. Some cameras will still focus and meter through a cut-off filter with few problems while others will not. The viewfinder of a point-and-shoot digital camera will not be darkened by a filter placed in front of the lens (one of the few times this is an advantage).

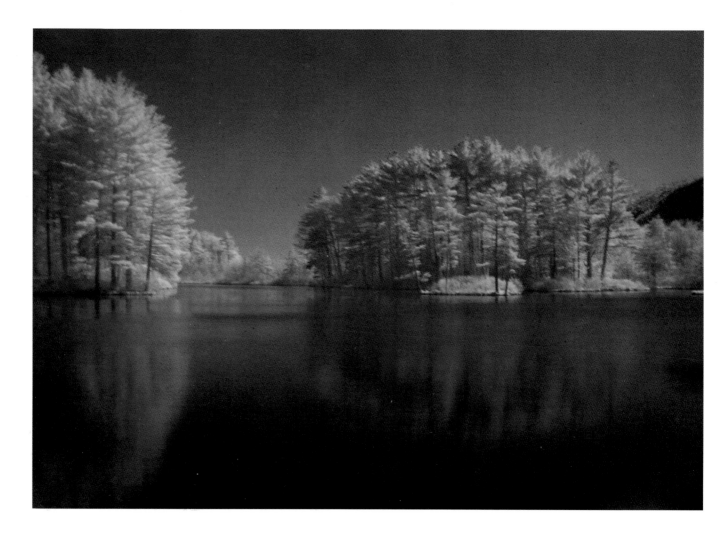

This infrared image was captured with a point-and-zoom digital camera fitted with an 87 glass filter. The image is somewhat dark and needed some manipulation to enhance the infrared effect.

Example 6: Digital Camera Infrared Images
(Adobe Photoshop, Pixel Genius PhotoKit)

The photos in this example were all infrared captures made with an 87 glass filter handheld against the lens of a point-and-zoom digital camera. The image of the lake has extremely low contrast, so Photoshop Levels (Image > Adjustments > Levels) was used to adjust the overall appearance of the scene. The dialog box of a typical histogram of a low-contrast IR digital capture is shown. The first step is to move the two outer arrows inward so they align with the first recorded data on the histogram. Next, adjust the center arrow left or right for a final adjustment. Any imaging software with a Levels adjustment can be used to perform this correction. You may also want to adjust the contrast as well, using whatever tools are available in your software. In Photoshop, I usually make contrast adjustments using the Curves function.

In addition to the levels adjustments and contrast refinements made with Photoshop, PhotoKit's Burn Top function was applied to darkened the sky at the top of the image.

The Levels dialog box shows a typical histogram for a low-contrast IR image.

Light, Camera Filters and Digital Cameras

The World Wide Web is the best source of information on the latest equipment and software used in digital photography. Consequently, the contact information in the Appendix section is by website.

Information on the Qualities of Light

There are many websites that contain information on the qualities of light beyond the information present in this book. There are also discussions regarding the quality of different light sources on the websites of many working photographers. In addition, many of the manufacturers of lighting equipment have educational materials concerning the photographic qualities of light on their sites. Most search engines will turn up these presentations using such key phrases as "Kelvin Scale Photography," "Photographic Light" or the name of a lighting manufacturer.

For a background discussion on the Kelvin Scale visit the Windows to the Universe site <www.windows.ucar.edu>.

The Professional Photographers of America also has a section on light and color at <www.kendricksdesignerimgs.com/lt-color.html>.

Filter Information

The websites of filter manufacturers are a good primary source for information on what filter types are available as well as sizes and designs. The list that follows contains URLs for the brands mentioned in this book. Camera filters can be purchased from most photographic stores, but there are also a few small companies that specialize in selling filters These sites very often carry information on the use of filters as well as helpful FAQ sections along with links to filter manufacturers. You are also more likely to obtain advice from the customer service departments at these specialized retailers.

The Filter Connection <www.2filter.com>

The Filterhouse <www.filterhouse.com>

The SRBFilm Service <www.srbfilm.co.uk>

Camera Filters.Com <camerafilters.com>

The Camera People <www.camerapeople.net>

Camera Filter Manufacturers

Cokin <www.cokin.fr>

Cromatek/Lastolite <www.lastolite.com>

Eastman Kodak Company <www.kodak.com>

Harrison & Harrision a selection of H&H Filters can be seen at Birns and Sawyer <www.birnsandsawyer.com/cdva-filters-harrisonharrison.htm>

Heliopan <www.heliopan.de>

Hitech/Formatt <www.formatt.co.UK>

Hoya <www.hoya.com>

Kenko <www.vertexsupply.com/kenko/index.html>

Lee <www.leefilters.com>

Lindahl <www.lslindahl.com/lindahl/catalog.htm>

Schneider B+W <www.schneiderkreuznack.com>

Singh-Ray <www.singh-ray.com>

Sunpak <www.sunpak.com>

Tiffen <www.tiffen.com>

In addition, many camera manufacturers offer an extensive line of filters. A web search of each camera company's name should yield a URL that will provide additional information on filter products.

Other Products

Gossen Meters <www.gossen-photo.de>

Hoodman Digital Camera Hoods <www.hoodmanusa.com>

Lens (and Filter) Test Charts <www.normankoren.com/Tutorials/MTF5.html>

Minolta Flash Meter VI <www.minolta.com>

Information on Digital Cameras

There are many manufacturer's websites, such as Canon, Minolta, Nikon, and Olympus, that contain information about digital cameras. A simple name search will turn up the URLs for most companies. Other websites concerned with digital cameras are run by individuals and associations and contain reviews along with chat boards where personal experiences and opinions are given. Using search phrases such as "Digital Camera Information" or "Digital Camera Reviews" will turn up most of these sites. Here are a few to get you started:

Steve's Digicams <www.steves-digicams.com>

Digital Photography Review <www.dpreview.com>

Moose Peterson's Wildlife Research Photography <www.moose395.net>

Digital Outback Photo <www.outbackphoto.com>

Ron Galbraith DPI <http://216.197.110.125/bins/index.asp>

Manufacturers of filter software programs are constantly up grading or otherwise changing their programs as well as issuing whole new programs. Throughout Chapters Four through Six, the author has used the main functions of available programs in order to offer a representation of what can be done with these software programs. The reader is encouraged to consult the website of any program they find interesting to see the latest version as well as any new offerings.

Adobe Photoshop <www.adobe.com>

Alien Skin Image Doctor <www.alienskin.com>

Andromeda <www.andromeda.com>

Applied Science Fiction <www.asf.com>

Asiva Photo <www.asiva.com>

Auto FX <www.autofx.com>

B+W/Schneider<www.schneiderkreuznack.com>

Binuscan PhotoRetouch <www.binuscan.com>

Color Mechanic <www.colormechanic.com>

Fred Miranda <www.fredmiranda.com>

Grain Surgery <www.visinf.com>

ImageAlign <www.grasshopperonline.com>

NAAP (National Association of Photoshop Professionals) <www.photoshopuser.com>

Nik Multimedia Dfine, nik Color Efex, penPalette <www.nikmultimedia.com>

Photographics iCorrect Professional <www.picto.com>

Pixel Genius PhotoKit <www.pixelgenius.com>

Quantum Mechanic Pro <www.camerabits.com>

Silver Oxide <www.silveroxide.com>

Vivid Details Test Strip <www.vividdetails.com>

RAW File Readers

Information on the proprietary RAW File software used by digital cameras can be found at the individual camera manufacturer's website.

Noise Reduction for the PC

For a noise reduction program that also uses camera profiles like nik Dfine but is available only for Windows, visit Neat Image <www.neatimage.com>.

Information on Using Filters with Digital Cameras

A strong case for using optical camera filters on digital cameras—as opposed to relying on software—has been presented along with other camera filter information at dpFWIW <www.cliffshade.com/dpfwiw/filters.htm>.

Index